IMAGES
of America

THE STEAMER
ADMIRAL

D1600120

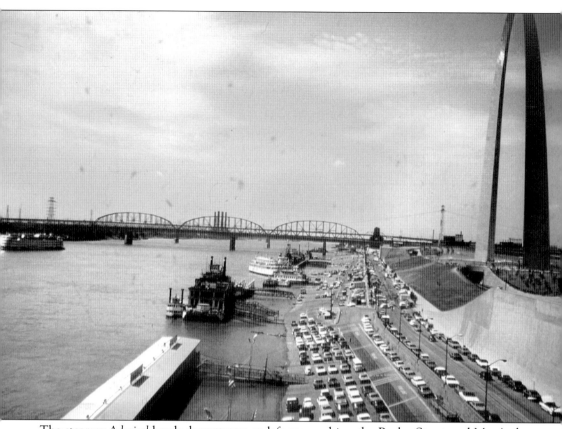

The steamer *Admiral* heads downstream at left approaching the Poplar Street and MacArthur Bridges. In front on the near shore is the *Streckfus* wharfboat, the restaurant boat *Becky Thatcher* with the little boat *Mississippi Belle*, the harbor boat MS *Sam Clemons*, and the overnight passenger steamer *Delta Queen*. On the right, the Gateway Arch gleams. (Capt. Jim Blum.)

ON THE COVER: The steamer *Admiral*, carrying a large load of passengers, begins a daytime excursion. The *Admiral* is turning out into the Mississippi River before straightening out to head south. Behind her is the restaurant boat *Becky Thatcher*, the harbor boat MV *Huck Finn*, and the Gateway Arch within the Jefferson National Expansion Memorial. (Capt. Jim Blum.)

IMAGES
of America

THE STEAMER
ADMIRAL

Annie Amantea Blum
Foreword by John N. Hoover

ARCADIA
PUBLISHING

Published by Arcadia Publishing
Charleston, South Carolina

Printed in the United States of America

Library of Congress Control Number: 2016961108

For all general information, please contact Arcadia Publishing:
Telephone 843-853-2070
Fax 843-853-0044
E-mail sales@arcadiapublishing.com
For customer service and orders:
Toll-Free 1-888-313-2665

Visit us on the Internet at www.arcadiapublishing.com

To my husband, Capt. Jim Blum, and to our children Angela Ruth and Paul David.

CONTENTS

FOREWORD

So many of the fine Arcadia Publishing titles focus on places on the land: town and cities, neighborhoods and regions, and the ways in which stories and memories of churches, businesses, and streets remind us of the historical legacies of these various communities and their bygone glories. In this new book, Annie Blum offers something different in the series—the story of one treasured riverboat, not moored or tied down but seemingly always in motion, to the delight of its thousands of past passengers. Yet the tradition, the rich history, and nostalgia that the *Admiral* created is indeed as deep as any of previous histories of cities and customs in this series. In many ways, the *Admiral* formed a community of river excursionists unlike any before or since. Based in the great river town of St. Louis, the pride of the fleet of a proud and creative family-owned company of entrepreneurs—the Streckfuses—and lasting through wartime and postwar generations, this fine old craft became synonymous with the old glory days of St. Louis's marriage with the Mississippi. It was a tradition for families to ride this great boat in the summertime, with fathers fondly explaining the history of the city to their children and mothers proudly showing off their children to other families, in the social occasion that was indeed these river rides, with everyone rapt by the views from the decks, and all having the trip of a lifetime. Families returned over and over again, the way people in New York visited Central Park or Coney Island, or San Franciscans visited Union Square, or Chicagoans Wrigley Field or Navy Pier—it was a tradition born out of love and a special heritage a community possessed with a very special river and its stately king of vessels on that awe-inspiring waterway.

The St. Louis Mercantile Library, founded in 1846, grew up with the city for which it formed its first library and eventually became a distinguished historical resource used internationally, one of the largest collections of transportation history in the nation. The library is proud to have worked with Blum on this project to make these pictures of indigenous river life in St. Louis from a bygone era better known. The library could have hoped for no more enthusiastic partner than the writer of this book, who is part of the *Admiral*'s history herself, who lived that history in so many ways, from the time this fine vessel proudly coursed the Mississippi, to the present, as she has been engaged in meticulous research that the reader is invited to share and be transported once again along the Mighty Mississippi in a moving scrapbook of river memories of the glory days of the excursion boats.

—John Neal Hoover
Director, St. Louis Mercantile Library

ACKNOWLEDGMENTS

I express many thanks to:

God, chief source of inspiration and ability.

My father, Michael F. Amantea, for teaching the magic of the Mississippi River to me and for helping me get a job on the steamer *Admiral*.

Capt. William F. Carroll for the inspiration and energy to preserve the Streckfus artifacts, the wisdom to gift them to St. Louis Mercantile Library, and for giving me the job on the steamer *Admiral*.

John Hoover, director of St. Louis Mercantile Library for his care of the Capt. William F. and Betty Streckfus Carroll collection and for believing in my abilities to write this book.

My husband, Capt. Jim Blum, for the errands, pictures, corrections, and moral support.

Unless otherwise noted, all images appear courtesy of the St. Louis Mercantile Library.

INTRODUCTION

John Streckfus was born in 1856 and married Theresa Bartemeier in 1880. John was a grocer who lived in Rock Island, Illinois, close to the Mississippi River where it was common at that time to send and receive goods by boat. It would make sense that he realized that instead of paying to transport his goods, he could buy his own boat. This is the beginning of the story of how one man built a historical family corporation and a line of riverboats on the Mississippi, Ohio, and Illinois Rivers, ending with the steamer *Admiral*. All of this was accomplished because John was far-sighted, clever, and inspired by an idea.

John Streckfus bought his first boat in 1889, the steamer *Verne Swain*, from the builder David Swain for $10,000. She was a rather small boat, only 22 feet wide and 120 feet long, but she was a fast boat and had three decks and a calliope. She was put to work carrying merchandise and passengers on a daily round trip leaving Clinton, Iowa, at 7:00 a.m. and arriving at Davenport, Iowa, at 10:00 a.m., with stops in between so there could be time for shopping, appointments, and errands, then leaving Davenport at 3:00 p.m. and returning home to Clinton by 8:15 p.m., seven days a week. At this point, Streckfus did not have a license to run a boat, so he hired others to take care of the legal requirements while earning a license. Streckfus bought a second steamer with the measurements of 73 feet long by 126 feet wide named *Freddie* in 1891, and that same year, earned a master's license, which gave him the title of "Captain;" he gradually became known as "the Commodore." Two years later, he took the big step of incorporating his Acme Packet Company. In 1893, he sold the *Freddie* to the US Army Corps of Engineers and, by 1894, had an engineer's license, making him a "double ender," a person with licenses in both the deck and the engine room. In 1896, Captain John bought his third boat, the *City of Winona* (126 feet long by 25 feet wide), so that one of his boats departed from opposite ports each morning with one leaving Clinton while the other was leaving Davenport. By 1900, Streckfus had purchased three boats, earned two licenses, incorporated, made full use of his boats, and formed a growing business, in just 11 years.

In 1900, the Commodore had three wooden hull steamboats fueled by coal, with stern wheels, called packets. A packet is a boat that carries freight and people on either daily short trips or on overnight trips. The boats made daily trips, and on weekends and some evenings, a band would be hired so that passengers could buy tickets to a moonlight dance excursion. When there were too many people wanting to board for a dance trip, the captain would lash a barge decorated to look like a boat in order to take on more passengers. This barge was known as the *Little Vern*. Even with all the work and planning he was putting in, the Commodore could look around him and clearly see that the rails were carrying more trains and that people were making use of them. Already in the spring of 1867, the Baltimore & Ohio Railroad could take a person from Baltimore to St. Louis via Cincinnati, linking the Atlantic Ocean to the Mississippi and Ohio Rivers. The Rock Island Railroad had completed the first bridge over the Mississippi River at Davenport, Iowa, in 1856. The Commodore and his wife had a family of nine children, and the picture of what was happening would seem clear to a discerning person—just how long could the typical packet steamboat continue profitably? The Commodore went to the E.J. Howard & Company boat builders in Jeffersonville, Indiana, across the Ohio River from Louisville, Kentucky, to order a new boat. The plans were drawn and the completed boat was different, even revolutionary, surely the product of forward-thinking minds. The name of the new boat was the steamer *J.S.*, named after Capt. John Streckfus himself. It was built completely of wood with a sternwheel, and it burned coal to make steam. How was it different? The *Waterways Journal* wrote that the new boat had a ballroom cabin, was otherwise built differently from the ordinary boat, and that the Commodore never copied anyone. The boat was designed mainly for excursions, although she could still take passengers and goods on short transfer trips. The boat's only staterooms were on the top deck in the Texas (an area near the pilothouse with living space for officers or family), and were for employees and guests. There was a main saloon or dance floor, a large dining room on the boiler deck, a soda fountain,

and a calliope. The *J.S.* measured 175 feet long and 33 feet wide. By 1910, the Commodore had sold the *Verne Swain*, received permission to have a bar on the new boat, redecorated the *City of Winona* and renamed her the *W.W.*, and had a successful decade of running the *J.S.* as a day packet, excursion boat, and a tramp boat going as far as New Orleans. A tramp, or tramping, boat carried crew and orchestra on board and went from town to town to run excursions. It was a smart idea: instead of staying in one place waiting for people to come to the boat, the boat could go to the people. This was done with the help of an advance man who worked the towns ahead of the boat, selling tickets and generating publicity. All the Commodore's children worked on the boats, and gradually, all the boys earned captain licenses. There was a general feeling of success.

Then something happened. The steamer *J.S.* was running on the upper Mississippi River on July 2, 1910, with 1,500 passengers on board, when it burned to the waterline. She was two miles above Victory, Wisconsin, just opposite Bad Axe Bend. Fortunately, due to the skill of captain and crew, the boat was run aground on Bad Axe Island and all aboard were able to get off safely, except for a woman passenger and a crew member in the boiler room. The company paid divers to look at the sunken boat, but it was a total loss. The family truly loved the *J.S.* because she was their first big boat and they had helped design her; she was a symbol of success. Years later, Captain John's sister Mae would still tell the story of how she had just gotten back from visiting her sister in the east and lost all the new clothes she bought in the fire. At the end of 1910, the Commodore was left with only the steamer *W.W.* and the *Little Vern* barge. Always flexible and optimistic, he moved on. At the end of the year, he reformed his company into the Streckfus Steamboat Company with 14 stockholders, and in 1911, he moved the headquarters to St. Louis, Missouri, with an office downtown and a landing site on the Mississippi River. At the same time, the Commodore had something new in mind: an excursion boat with a steel hull. It made sense to have a steamboat that would last longer and demand less maintenance. He went to the Dubuque Boat and Boiler Works in Dubuque, Iowa, for a drawing and a plan for such a boat. In 1911, before work could begin on the new boat, the Commodore got the opportunity to buy out the Diamond Jo Steamboat Line from the brother-in-law of Joe Reynolds, who was the agent for the company. After much exchanging of prices, the Commodore agreed to buy Reynolds's boats for $150,000. He had $75,000 in cash and made notes at six percent for the balance to be paid over a period of four years. Surely, the Commodore made this decision based on the vast possibilities of the purchase. For the money, he would get four boats, a small shipyard, and offices and storage buildings on various parts of the Mississippi-Ohio River system. The four boats—the steamers *Dubuque*, *Quincy*, *Sidney*, and *Saint Paul*—were made of wood, coal fired, and designed as packet boats with overnight cabins, but the amount of money expended could not pay for one metal hull boat. The metal hull boat would have to wait while the Commodore plotted his new purchase.

The steamer *Sidney* was the first boat to be converted for excursions. By May 1911, she was running excursions on the Mississippi River. The other three boats (the steamer *W.W.* was sold in 1915) continued to have passenger service and excursions to St. Louis, St. Paul, and New Orleans between 1911 and 1917. The company was competing against increased rail service and made different kinds of deals in conjunction with the railroads. For example, a passenger could travel one way by rail and one way by water, and the tickets could be bought at either end for the whole trip. Starting in 1917 with the *Saint Paul*, each boat was converted into service for excursions. The *Saint Paul* kept her name and went tramping first on the Mississippi River and then on the Ohio River. The *Quincy* was converted in 1919 and renamed the *J.S.* The *Dubuque* was renamed the *Capital* and remodeled, and finally, in 1921, the *Sidney* was redecorated and became the *Washington* to tramp on the Ohio River.

Many companies wintered their boats in Paducah, Kentucky. In 1917, the Commodore decided to keep his boats in Davenport, Iowa, instead. That is why his boats escaped a damaging ice gorge out of the Tennessee River, which sank nine boats at Paducah. This caused an opportunity for the Commodore to take on greater business in St. Louis. The Commodore died in 1925 and was not able to see the realization of his goal of a steel hull boat. His son Joseph Streckfus became the president of the company and organized a new corporation named Streckfus Steamers, Incorporated. In 1931, the company bought a metal hull boat named *Cincinnati* and took it to St. Louis. This boat was an

overnight packet, and had a unique design in the cabin. There was a balcony, or mezzanine, that made a two-deck main cabin with passenger rooms above and below. Captain Joe had the *Cincinnati* taken to St. Louis, where all the upper works were taken down to the basic hull. A new boat was built on the steel hull, and in 1933, the excursion steamer *President* made her maiden voyage out of St. Louis. Imagine a steel boat, oil fired and five decks high, designed to carry 3,000 passengers with a huge ballroom, a mezzanine, and a restaurant deck; the manifestation of the Commodore's dream.

The steamer *President* ran as a tramping boat from St. Louis all along the upper Mississippi to St. Paul, Minnesota. Between 1933 and 1938, five boats roamed the rivers under the Streckfus standard until the *J.S.* and the *Washington* were scuttled. The *Saint Paul* was remodeled and renamed in the winter of 1939–1940 and ran two years as the *Senator* before ending service. The *Capitol* was dismantled in 1945.

Capt. Joe Streckfus and his brothers bought another steel hulled boat called the *Albatross* in 1935. She had served as a railroad transfer (ferry) boat hauling trains across the Father of Waters at Vicksburg, Mississippi, before the bridge was built. The boat was taken to St. Louis just north of the Eads Bridge, where the upper works were taken down and replaced with a superstructure five decks high, as fireproof as possible, big enough to hold 4,000 passengers with a ballroom that could hold 2,000 people, a mezzanine, air conditioning, and Art Deco design throughout. The new boat was named the *Admiral* and made her maiden voyage in 1940; in her, the Streckfus Family and Company had reached their acme.

From 1940 until 1978, the steamer *Admiral* ran excursions out of St. Louis every summer, days and nights. The steamer *President* went to New Orleans permanently in the early 1940s and ran similar trips all year. In 1973, the *Admiral* was converted from steam to diesel power. In 1963, the company built several metal boats holding 400 passengers each and used for one-hour harbor trips and night dinner dance cruises. These were especially popular for tourists who did not have enough time to ride the big boat.

The *Admiral* worked her last summer in 1978. During the 1979 inspection, the Coast Guard informed Streckfus Steamers that the *Admiral* needed a new hull.

The world of entertainment was changing in the 1970s. Many large single-screen theaters closed, old line amusement parks closed, public transportation to venues like the *Admiral* were discarded for the private automobile, and the American motorist's "park at the front door" philosophy prevailed. The costs of converting the *Admiral* and *President* to diesel propulsion, coupled with declining revenue and ever more stringent pollution regulations and increasing maintenance and repair costs resulted in funds not being available for hull replacement.

Sensing that the large passenger excursion boat operations were headed to extinction, the company advertised the *Admiral* for sale in the Wall Street Journal.

A Pittsburgh, Pennsylvania, businessman, John Connelly, outbid a scrap dealer for the *Admiral* in the spring of 1981, and sold the boat to a St. Louis group called the Admiral Partners. The entire Streckfus Company was sold by February 1984. The Admiral Partners brought in an amusement company that heavily remodeled the shell of the boat into an ill-starred amusement center, which opened in March 1987.

That venture failed within a year, and the entertainment center sat vacant for several years at a St. Louis dock before being reacquired by Connelly in 1990. He also bought the *President* and turned both boats into the latest craze, floating casinos, with the *Admiral* in St. Louis and the *President* in the quad cities area of Iowa. As these casinos morphed into dockside structures, the *Admiral* changed owners again in 2006. This time, the vessel became part of a surplus asset of the owner of a new hotel/casino complex just up the hill from the now rapidly declining *Admiral* Casino. Just one day prior to the state of Missouri pulling the *Admiral* Casino's licenses, the Mississippi River flooded, causing access to the *Admiral* Casino to be cut off.

The end had come. The grandest excursion boat ever built, in its incarnation as a casino, was sentenced to the scrapper's torch. The *Admiral* was towed on July 19, 2011, to Lohr Bros. Marine, south of the city, to be scrapped. The hull was towed to mile 14 on the Tennessee River shortly after to be cut into pieces for the furnace. The final curtain fell on October 3, 2011.

One

PRELUDE

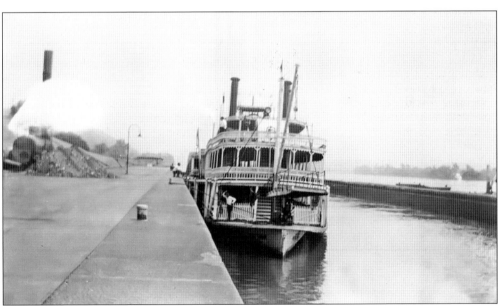

The first boat purchased by John Streckfus was the steamer *Vern Swain*. Built by David Swain at the Swain Shipyard in Stillwater, Minnesota, she was sold to Streckfus in 1889 for $10,000. The boat was only 120 feet long and 22 feet wide, but she was fast and big enough to carry passengers and merchandise to neighboring towns. She was sold to Dixon Brothers of Peoria, Illinois, in 1900; they appropriately changed the name to *Speed*.

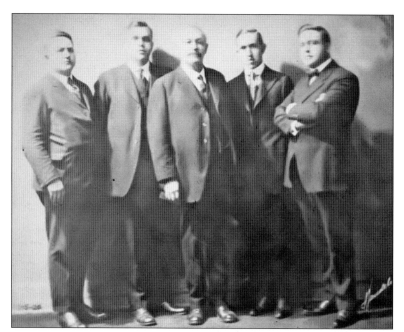

Nine children were born to John and Theresa Streckfus. Not all lived to adulthood, but those remaining worked on "Papa's" boats. All the boys earned master's licenses to captain. From left to right are Roy, Joseph, the Commodore, Vern, and John Jr.; Joseph was the oldest and most immediate heir.

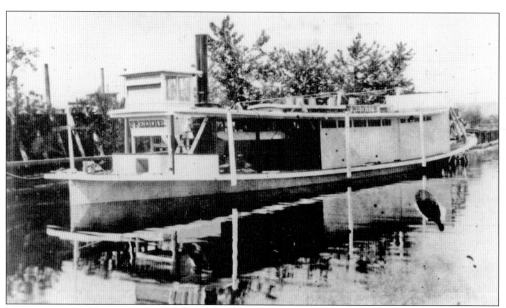

The steamer *Freddie* was built at Kalke Boatyard in Rock Island, Illinois. It was a coal-fired wooden hull boat only 72 feet long and 16 feet wide. Capt. John Streckfus bought her as his second boat in 1891. He used her to haul goods and people between Buffalo, Iowa, and Davenport, Iowa, a distance of 12 land miles, and for excursions to Frahn's Park. The *Freddie* was sold in 1893 to the US Army Corps of Engineers, which renamed her the *Mac*.

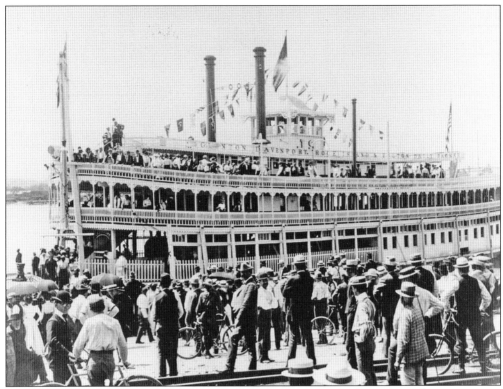

Until 1901, all the Commodore's boats were packets, carrying both freight and passengers. In 1901, he contracted for the design and construction of a new boat at the Howard Shipyard in Jeffersonville, Indiana. This boat, named the *J.S.*, was intended for excursions only and marked great growth in the river affairs of the family.

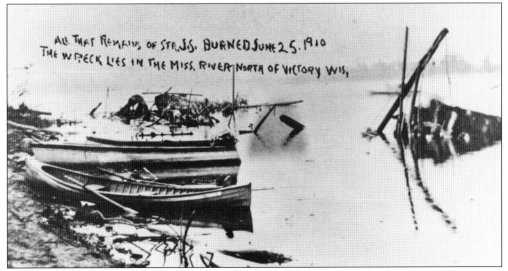

In 1910, while on an excursion, the steamer *J.S.* burned to the waterline at Bad Axe, Wisconsin. The pilot on duty was able to get the boat to a nearby island, and all were saved except two people. Efforts were made to salvage the hull, but it was a hopeless case. This fire left the company with only one boat, the steamer *W.W.*

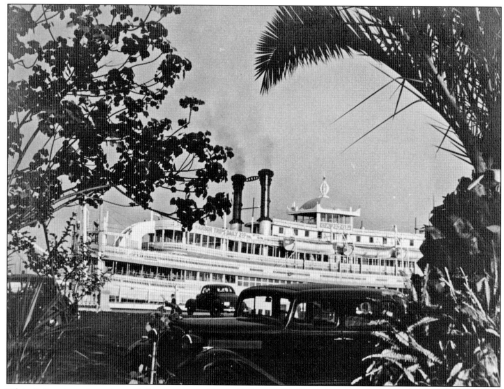

This is an exterior view of the steamer *Capitol*, formerly the *Dubuque*, a sternwheeler considered the "workhorse" of the company because she tramped all summer and offered daytime harbor and night dance cruises in New Orleans in the winter. She even continued to run harbor cruises in the New Orleans harbor during the first year the United States was in World War II.

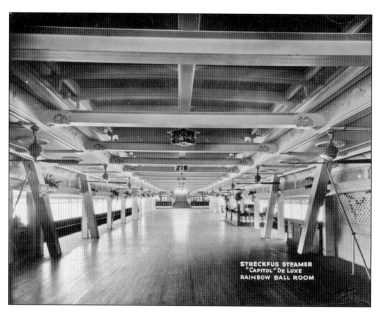

The most important form of entertainment on the excursion boats was live music. The Streckfus family was eager to provide popular and contemporary music using their own and local bands. Ads gave the names of the bands as incentive to ride. The ballroom, like this one on the steamer *Capitol*, was kept freshly painted and decorated, including seasonal details.

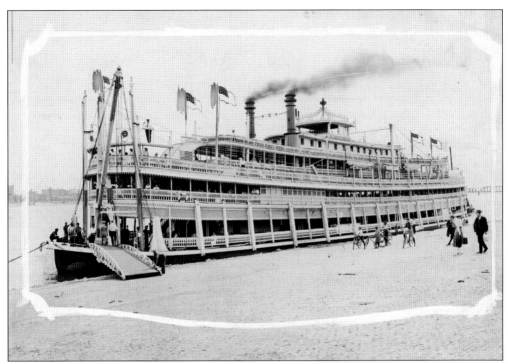

As can be seen by this exterior view of the steamer *Washington*, she was a wooden hull boat with a stern paddlewheel. She established a presence on the Ohio River for the company. The first headquarters on that river was in Cincinnati, Ohio, but was changed later to Paducah. She was retired and dismantled in 1938.

In 1921, the Streckfus Line remodeled the boat named *Sidney* into the steamer *Washington* to work the Ohio River. She had amenities such as a dining area, cafeteria, ballroom, and gothic steamboat styling similar to her sister boats and was often used for spring dances and proms by small river town schools.

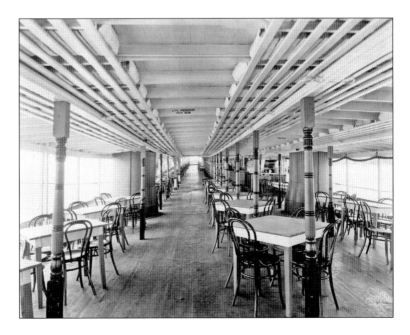

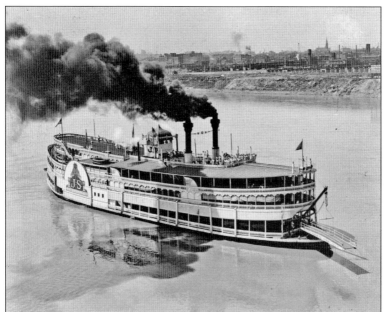

Another boat bought from the Diamond Jo Lines, the *Quincy* was renamed the *J.S.* Since the word "deluxe" appeared on the side covers of the paddlewheels, she was commonly known as the *J.S. Deluxe.* Her inside styling was lovely, and the first deck was especially welcoming, with cushioned seats and a fountain.

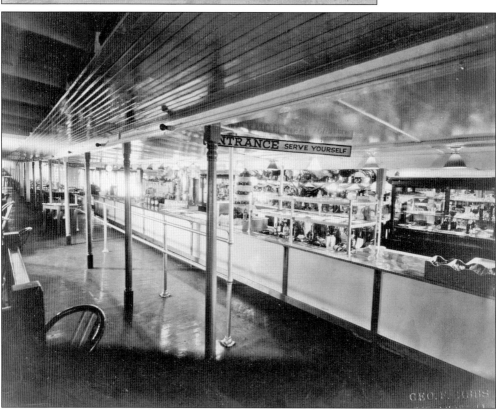

The Streckfus people were on the cutting edge when it came to providing passengers with top contemporary styles. After one member of the family went to New York and experienced service in the then-new dining cafeteria concept, the idea was used on the boats, as shown here on the *J.S. Deluxe.* A variety of foods could be kept hot and served easily.

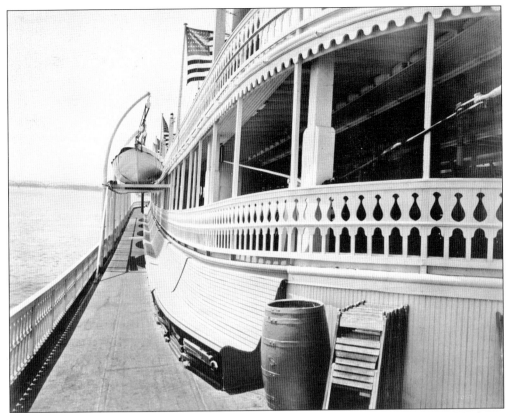

The flowing lines of Steamboat Gothic style are seen here on the promenade of a Streckfus boat. While beautiful and comfortable, these types of boats were also fragile in that they were made entirely of wood. Even those that were well maintained could fall prey to fires and snags in the river in the days when there were no locks and dams and no system to keep tree trunks and other dangers out of the water.

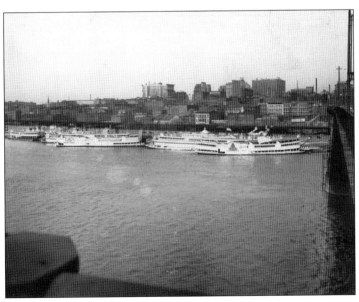

The steamer *J.S. Deluxe* is in the foreground with the *Saint Paul* and *Capitol* in 1920. These are three of the four boats obtained from the Diamond Jo Line. They were well maintained and well patronized, being popular for parties, reunions, proms, and other outings.

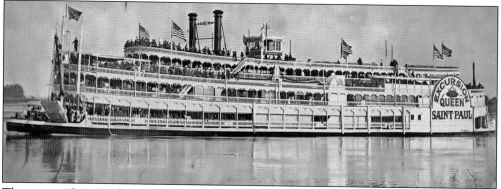

The steamer *Saint Paul* was rebuilt as an excursion boat in 1917 and tramped on the Mississippi River out of St. Louis. After 1921, the *Saint Paul* also ran on the Ohio River. She had five decks counting the promenade, and sidewheels. On each side of the boat, there was a decorative cover over the wheels with the name of the boat. The coal burned in the furnaces created heat that boiled water, making steam that pushed the paddlewheels to propel the boat.

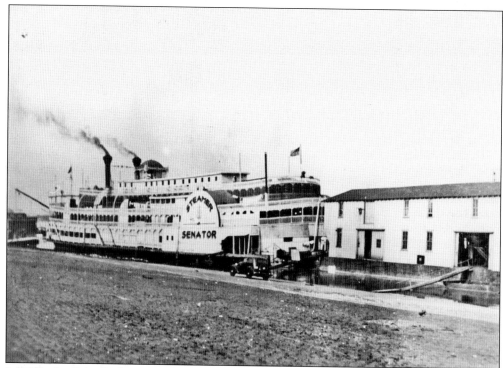

In 1939, the *Saint Paul* was overhauled and redecorated in the shipyard at Paducah, and given the new name *Senator*. Since she was popular and well known, she worked tramping excursions for two more years. Discouraged by the outbreak of World War II, the company took her to the harbor in St. Louis for use as a workboat and finally scraped her in 1953. In this picture, she is shown in St. Louis, with the two-deck wharfboat also bought from the Diamond Jo Lines.

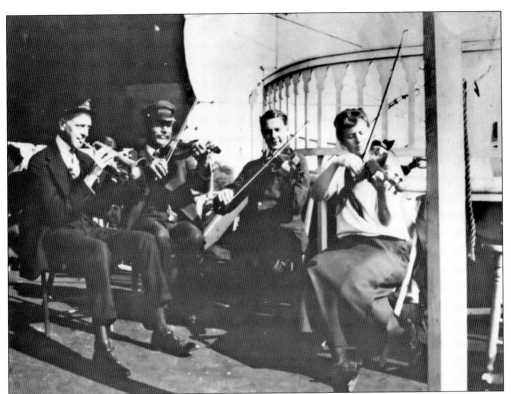

The Streckfus family members were musically inclined, and some played instruments. They insisted on well-played contemporary music in addition to well-known older tunes for the dances in the ballroom. During rehearsals, the Commodore would enjoy sitting in for a few pieces. Many musicians started or promoted their professional careers on the boats, including Fate Marable, Louis Armstrong, and Walter "Fats" Pichon.

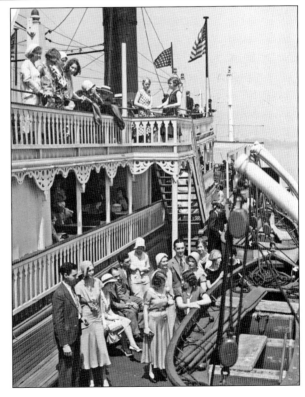

Tramp boats worked up and down a river, selling trips at each town with the help of an advance man, who set up advertising and sold charters. The crew, including the band, lived on the boat. The river trips lasted all day, and the night trips featured live bands and dancing from 8:30 or 9:00 p.m. until midnight. Outside promenades were popular for exercise and for viewing the river.

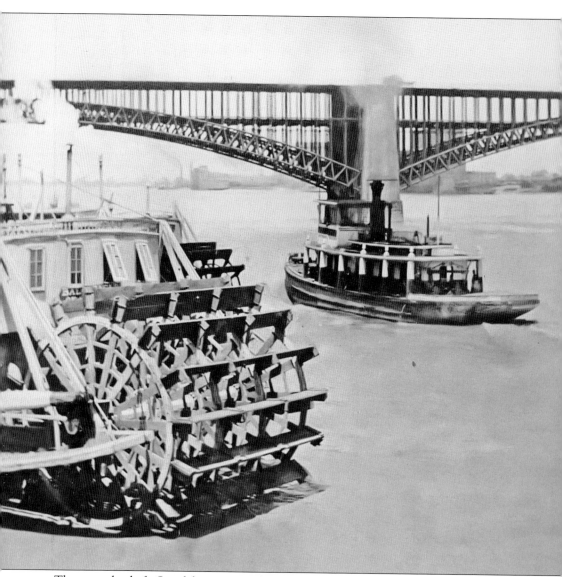

The sternwheel of a Streckfus excursion boat is tied up at dock while the Streckfus towboat *Susie Hazard* makes its way north. In the back is the Eads Bridge.

Two

THE METAL HULL BOATS

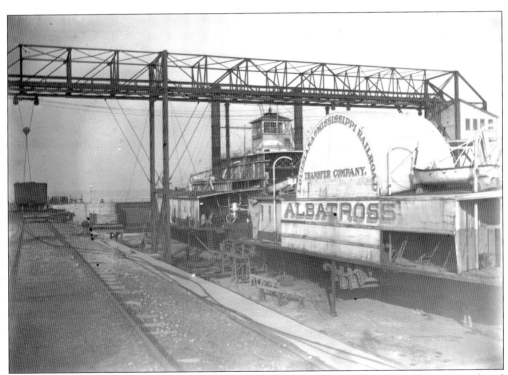

The steamer *Albatross* was a side-wheel boat, heavily built for a special function. She was a railroad transfer boat or ferry. She worked with her sister ship, the *Pelican*, at Vicksburg, Mississippi, where there was no bridge across the river. They would transfer or ferry trains from one side of the river to the other. After a bridge was opened in 1930, the *Albatross* sat unused until Streckfus bought her. According to some legends, the Albatross is good luck for sailors because it can fly a long way from land. On the other hand, it is considered bad luck to kill an Albatross.

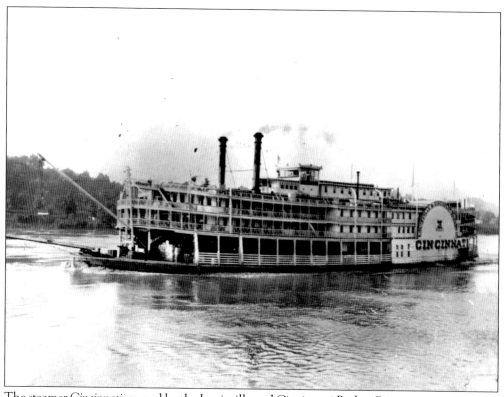

The steamer *Cincinnati*, owned by the Louisville and Cincinnati Packet Company, was equipped with side wheels, cabins, a dining room, and a two-level main salon. There was live music on Sunday night excursions, and she carried cars so that passengers could ride the boat to a point and then drive. Most of the cruises were between Louisville, Kentucky, and Cincinnati, with longer trips to New Orleans for Mardi Gras.

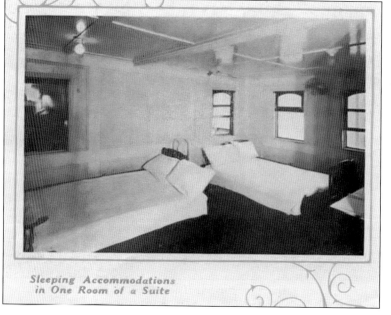

Sleeping Accommodations
in One Room of a Suite

On the packet boats, the rooms were comparatively small and intended for sleeping only, with bathroom facilities down the hall. The room on the steamer *Cincinnati*, as shown here, was typical. It was part of a suite probably intended for families, and such a room was naturally more expensive than a single room.

The unique feature on the steamer *Cincinnati* was the two-deck passenger cabin. There were passenger rooms off of the downstairs lounge and off the upstairs mezzanine. This idea would feature in other Streckfus boats.

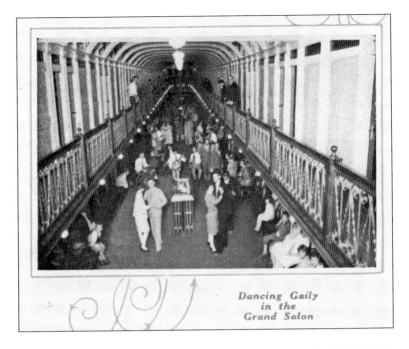

Dancing Gaily
in the
Grand Salon

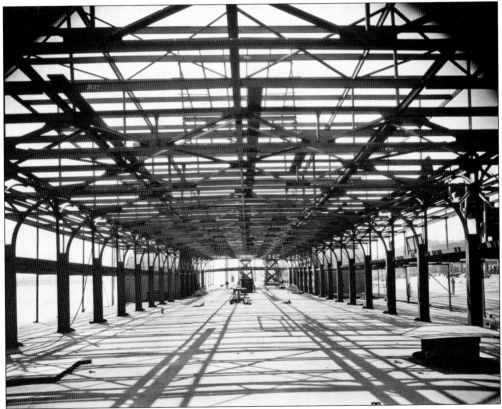

The *Cincinnati* was taken to St. Louis at the Streckfus wharf at the foot of Washington Avenue. The old boat was gradually replaced by a modern excursion superstructure.

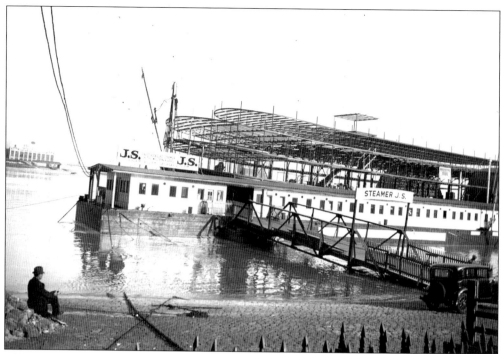

The half-finished new boat sits on the dock with the St. Louis skyline behind her. Work began in 1931 and attracted much interest until completion in 1933.

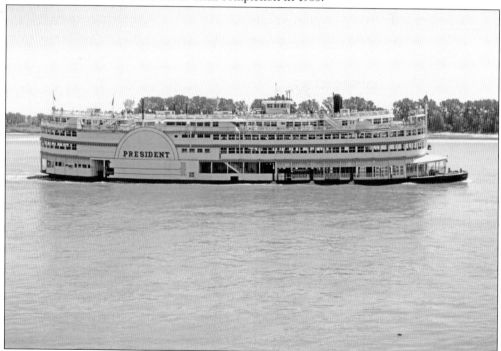

The completed new boat was named the *President*. Her design was more modern than the older boats, and she was longer at 285 feet. Whether viewed from the outside or inside, she was a beautiful, comfortable vessel worthy to be the fulfillment of the Commodore's dream for a metal boat.

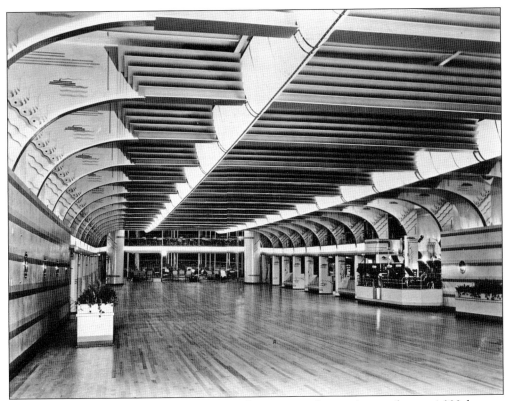

The ballroom of the steamer *President* was a handsome area with enough space for over 1,000 dancers. The panels in the ceiling were painted in many colors. The idea for the mezzanine came from the original *Cincinnati* and was a welcome place to listen to music and watch ongoing activities.

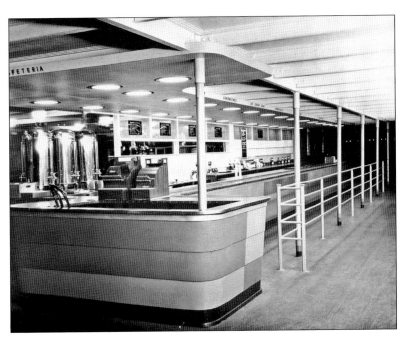

On the fourth deck of the *President* was the popular cafeteria, along with other food options, and a bar. Built as an open deck boat, she was closed in during the 1950s and could be heated when necessary.

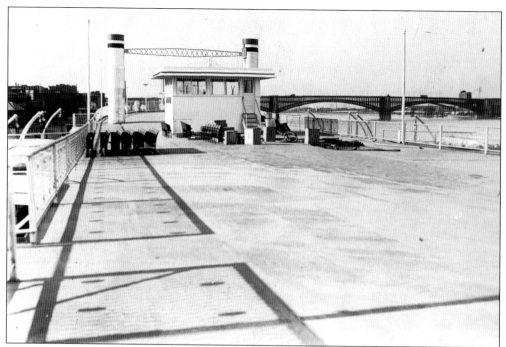

The roof, or lido, deck of the *President* had a pilothouse in the middle of the boat, and there was no Texas. After 1940, the *President* spent three years tramping, mostly on the upper Mississippi River, and then made her home permanently in New Orleans, running year-round harbor cruises and moonlight dance cruises.

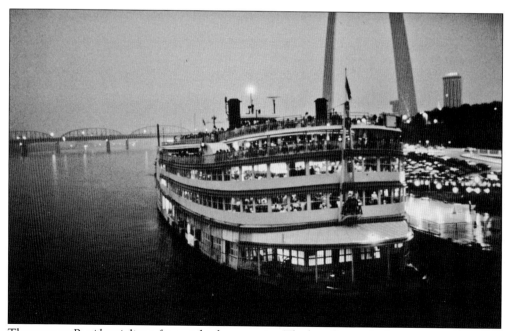

The steamer *President is* lit up for a night dance cruise. The bow featured a large canopy. The boat was five decks high and could hold 3,000 people. She was painted white and made her maiden voyage in 1933 to run excursions out of St. Louis.

These are samples of the brochures given out by the Streckfus Company on behalf of the steamer *President*. By this time, the boat had begun running out of New Orleans all year long on a permanent basis. Included is the map of the river trip, details about the boat, and news about the featured band.

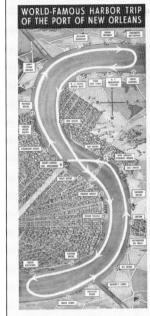

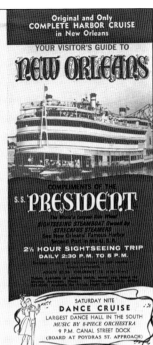

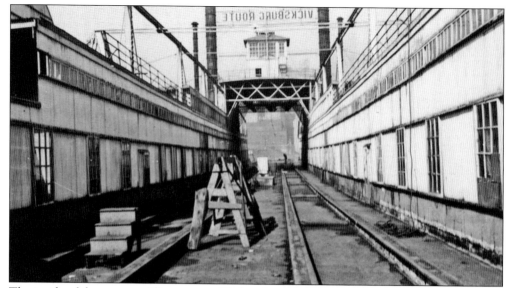

The inside of the steamer *Albatross* was filled with track for the trains. With longer trains, half at a time would be taken across and rejoined on the opposite shore. The sides of the Albatross provided for machinery, coal storage, and crew housing.

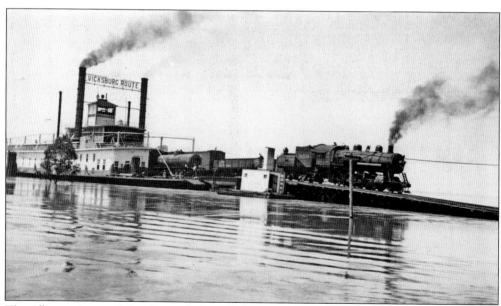

The *Albatross* is seen doing the work she was designed for: moving trains. A ramp on shore was equipped with tracks to match up to the boat, and another ramp was designed to bridge the gap between the shore and the boat.

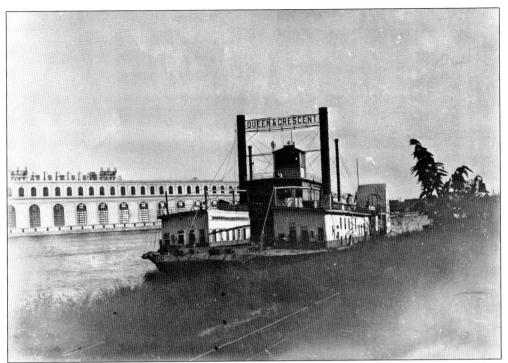

The steamer *Albatross* was built at Iowa Boat Works (later the Dubuque Boat and Boiler) in 1906–1907 for delivery to Vicksburg, Mississippi. In 1921, the *Albatross* was taken to Keokuk, Iowa, to be made longer in order to accommodate longer train cars.

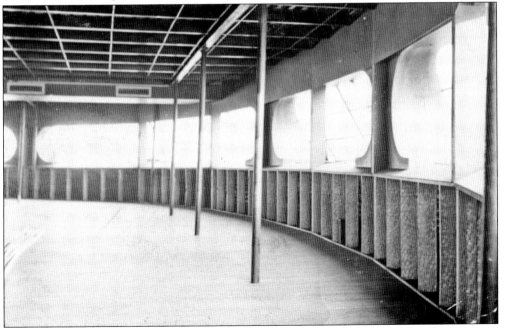

Upon arrival in St. Louis, the *Albatross* was tied up just north of the Eads Bridge. Crews started working and removed the upper parts down to the metal base hull. Gradually, metal parts went in and the boat started to reach up.

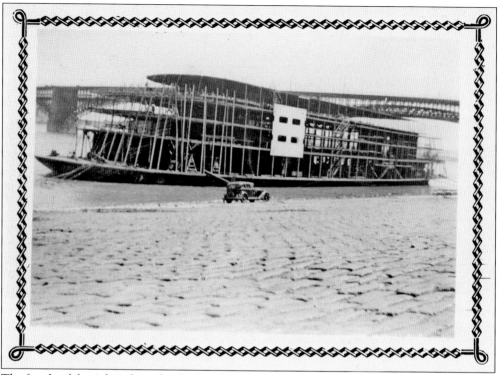

The facade of the *Admiral* was finished to the point where a sample of the outside covering could be tested as to appearance and quality.

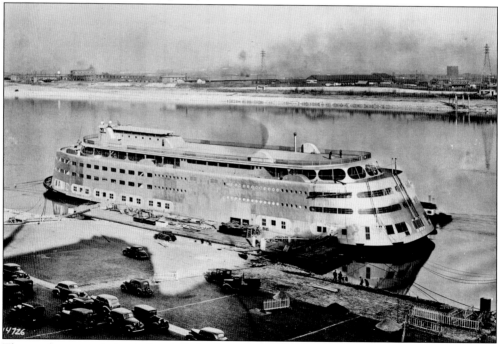

The new boat was obviously five decks high, made of steel, and as fireproof as possible. Even when incomplete, viewers could tell that the style was different, certainly not traditional.

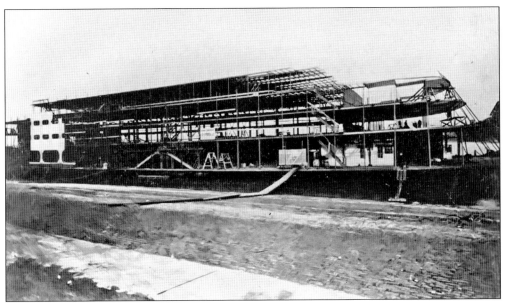

The building of the new boat on the levee caused great interest with the media and among those who walked on the levee. The company was very secretive and even denied knowing anything about it. To add to the surprise, no name was placed on it until right before the opening.

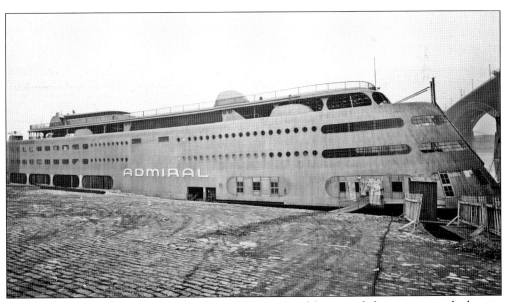

Finally, the name *Admiral* was posted on the completed boat, and she was painted silver in preparation for her first voyage in 1940. The cost of building her was $707,360.26. She was moved to the foot of Washington Avenue, and the trial run was on May 28, 1940.

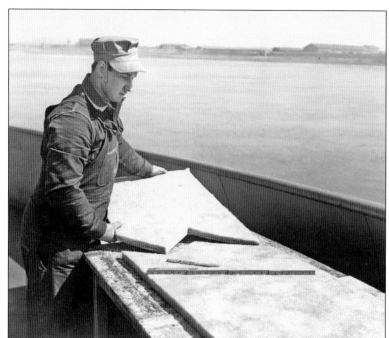

One of the *Admiral* workmen is cutting insulation to fit into spaces in the ceiling and walls before covering with the walls. After that came painting and other decorating.

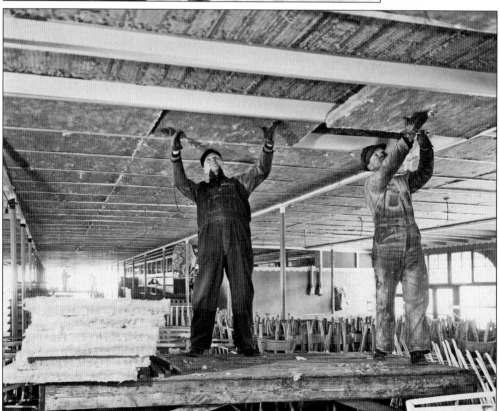

Two *Admiral* workmen fit the insulation into the ceiling of the fourth deck in the area where there would be tables and chairs for passengers.

The Streckfus Company bought the harbor boat *Susie Hazard* to help with the building of the *Admiral* and to lease to other river companies.

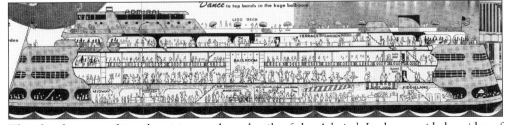

This sketch was used in advertising to show details of the *Admiral*. It also provided an idea of the boat's dimensions.

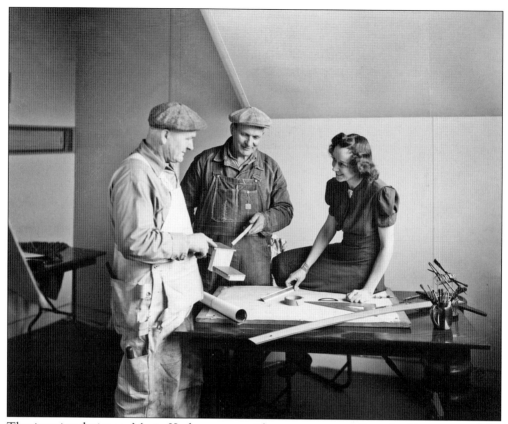

The interior designer, Mazie Krebs, meets with two men regarding the blueprints of the *Admiral* interior. She was part of the team that designed the boat. Her office later became the captain's office.

In June 1940, the steamer *Admiral* hosted a sophisticated maiden voyage. There were flower tributes from friends, and city officials, including the mayor, gave speeches.

Friends, sponsors, and special guests attended the gala at the *Admiral*'s premiere. Guests gathered in the bow until after the opening ceremonies, when curtains were drawn and guests were free to explore the boat.

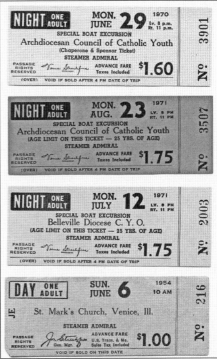

NIGHT	ONE ADULT	MON. JUNE **29**	1970 Lv. 8 p.m. Rt. 11 p.m.	Nº 3901

SPECIAL BOAT EXCURSION
Archdiocesan Council of Catholic Youth
(Chaperone & Sponsor Ticket)
STEAMER ADMIRAL
PASSAGE RIGHTS RESERVED ADVANCE FARE **$1.60** Taxes Included
(OVER) VOID IF SOLD AFTER 4 PM DATE OF TRIP

NIGHT	ONE ADULT	MON. AUG. **23**	1971 Lv. 8 PM Rt. 11 PM	Nº 3507

SPECIAL BOAT EXCURSION
Archdiocesan Council of Catholic Youth
(AGE LIMIT ON THIS TICKET — 25 YRS. OF AGE)
STEAMER ADMIRAL
PASSAGE RIGHTS RESERVED ADVANCE FARE **$1.75** Taxes Included
(OVER) VOID IF SOLD AFTER 4 PM DATE OF TRIP

NIGHT	ONE ADULT	MON. JULY **12**	1971 Lv. 8 PM Rt. 11 PM	Nº 2003

SPECIAL BOAT EXCURSION
Belleville Diocese C. Y. O.
(AGE LIMIT ON THIS TICKET — 25 YRS. OF AGE)
STEAMER ADMIRAL
PASSAGE RIGHTS RESERVED ADVANCE FARE **$1.75** Taxes Included
(OVER) VOID IF SOLD AFTER 4 PM DATE OF TRIP

DAY	ONE ADULT	SUN. JUNE **6**	1954 10 AM	Nº 216

St. Mark's Church, Venice, Ill.
STEAMER ADMIRAL
PASSAGE RIGHTS RESERVED ADVANCE FARE **$1.00** U.S. Trans. & Mo. Sales Tax Included
VOID IF SOLD ON THIS DATE

Tickets were issued for each trip. Groups could buy them at a discount and sell them to their members to make money for their organization.

- STREAMLINED - AIR·CONDITIONED -
- SUPERLATIVELY MODERN -

Presenting
A GREAT NEW STAR
for your
Entertainment
and Pleasure

This pamphlet printed for the first season of the long-awaited *Admiral* featured a sketch of the boat's bow and the mascot lil Admiral. The drawings were done by interior designer Mazie Krebs.

Advertising pamphlets and leaflets made use of images of the boat. The name of the band was used to encourage attendance. Advertisements extolled the fun of picnic days and romantic nights. The *Admiral* had many of the qualities and appearance of deepwater ships.

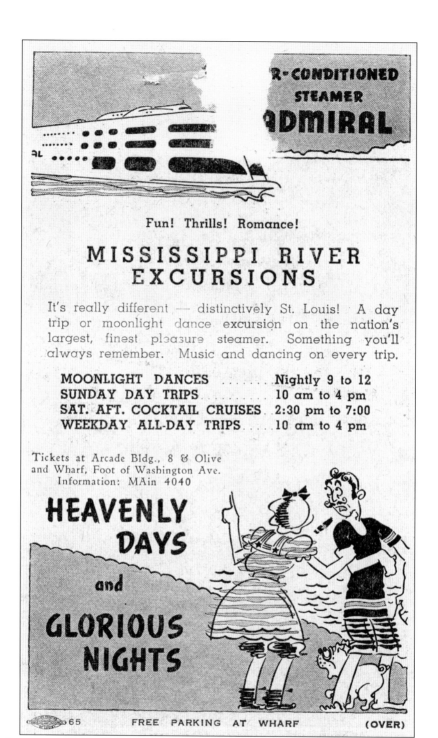

Fun! Thrills! Romance!

MISSISSIPPI RIVER EXCURSIONS

It's really different — distinctively St. Louis! A day trip or moonlight dance excursion on the nation's largest, finest pleasure steamer. Something you'll always remember. Music and dancing on every trip.

MOONLIGHT DANCES Nightly 9 to 12
SUNDAY DAY TRIPS 10 am to 4 pm
SAT. AFT. COCKTAIL CRUISES . 2:30 pm to 7:00
WEEKDAY ALL-DAY TRIPS 10 am to 4 pm

Tickets at Arcade Bldg., 8 & Olive
and Wharf, Foot of Washington Ave.
Information: MAin 4040

HEAVENLY DAYS and **GLORIOUS NIGHTS**

65 FREE PARKING AT WHARF (OVER)

This advertisement promises "heavenly days and glorious nights." The Streckfus family was very conscious of its reputation; they ran boats that had all the components of good fun, and at the same time, they were watchful to halt activities that might cause trouble. For example, at night, cameras had to be stored in the checkroom so that passengers did not have to worry about being photographed, something that would be impossible now.

Three

IMAGES OF THE ADMIRAL AND THE LEVEE

The *Admiral's* whole expanse from the bow looking back can be seen in this picture taken from Eads Bridge. It is easy to see the sheared side and the flow of pure Art Deco design. The center of the bow is marked by the support of the crow's nest. Truly, she was beautiful. (Capt. Jim Blum.)

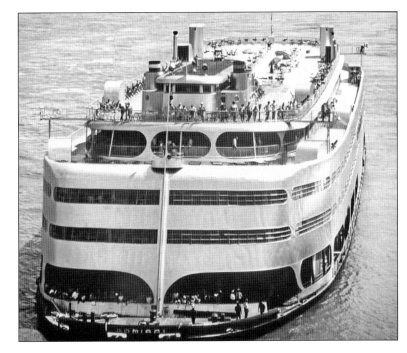

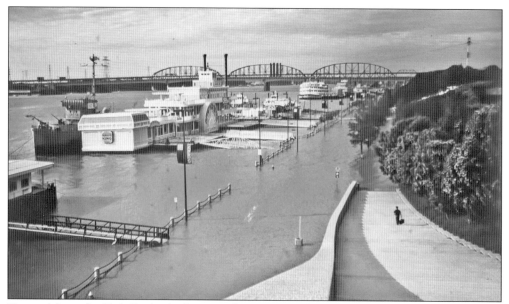

Pictured from the Eads Bridge looking south are a gangplank of the *Admiral*, the Burger King restaurant with a World War II minesweeper, the restaurant boat *Becky Thatcher*, the diesel passenger harbor boat *Huck Finn*, and in the distance, the steamer *President* and the restaurant boat *Lt. Robert E. Lee*. It was a period of high water, causing some of the gangplanks to be submerged. (Capt. Jim Blum.)

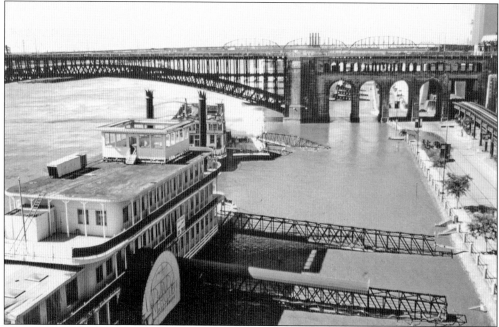

This is a view looking south through the Eads Bridge (which was completed in 1874), during a time of high water. Here, the Belle Angeline, a restaurant on a barge designed to look like an old riverboat, and the *Goldenrod* showboat can be seen. The *Goldenrod* operated from a spot close to the Gateway Arch, but here, in 1989, it is tied up north of the bridge in preparation for a move to St. Charles, Missouri. (Capt. Jim Blum.)

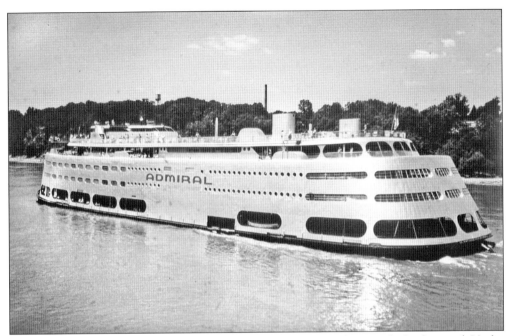

The stern and port side of the *Admiral* are seen with the Illinois shore in the background. Under the *Admiral* sign is an unadorned area without windows. Behind that is a paddlewheel, with another one on the other side. Side wheels like these were highly desirable because they made a boat quite maneuverable. (Capt. Jim Blum.)

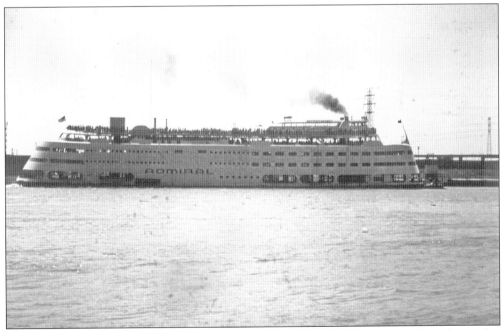

From this view of the *Admiral*, the starboard side and the outlines of the boat from flag to flag can be seen. In addition, the outlines of the calliope at the bow and the elevator shaft at the stern are visible. (Capt. Jim Blum.)

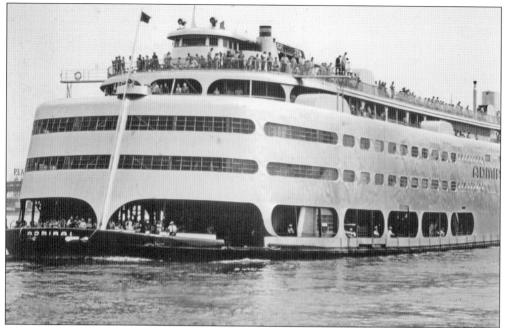

In this head-on view of the *Admiral*, it is easy to see the pilothouse on the top deck, the crow's nest hanging off the front, the bridges on each side, and the entrance to the boat. There are flying bridges on both sides, making it easier to see the shore when it is time to guide the boat into the landing site. (Capt. Jim Blum.)

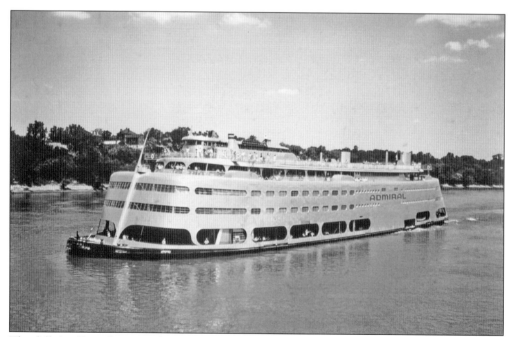

The full Art Deco lines can be seen in this view of the bow and port side of the *Admiral*. The generous use of windows allowed for good interior light and many views of the outside. (Capt. Jim Blum.)

There were three stages, or gangplanks, for boarding the *Admiral*. The one on the forward or northern end was used the most. At the end of that stage was a ticket seller and then a short walk on another stage before boarding the big boat.

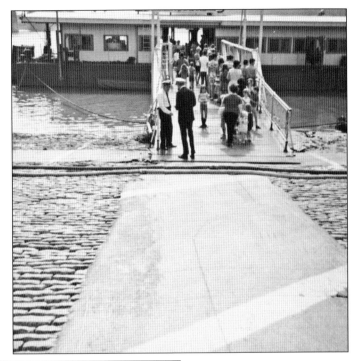

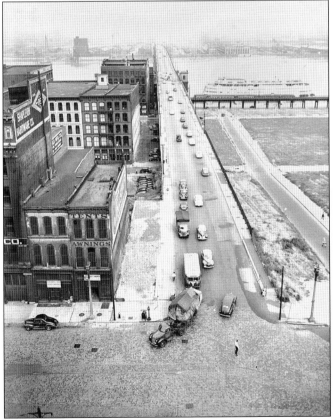

This view of the Eads Bridge facing east was taken from a high point. A steady stream of vehicle traffic is crossing the bridge, and in the background are the Mississippi River and the steamer *Admiral*. (The State Historical Society of Missouri Photograph Collection.)

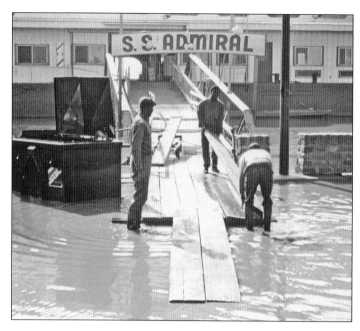

The Poplar Street Bridge was completed in 1967, and its height put limits on the *Admiral* in time of high water. Before that, the crew would build a makeshift stage using sturdy elevated planks of wood. At times, these stages would extend all the way across the street and up the opposite sidewalk, but the patrons' feet stayed dry, and the boat rides continued. After the bridge was built, the boat would have to cancel trips when there was extremely high water. (Capt. Jim Blum.)

After high water receded, there was a mass of mud, twigs, limbs, and assorted junk that had been brought down from river banks upstream. The City of St. Louis would clean the levee using high-power hoses. More dangerous was the tangle of waste that would block up at both ends of boats.

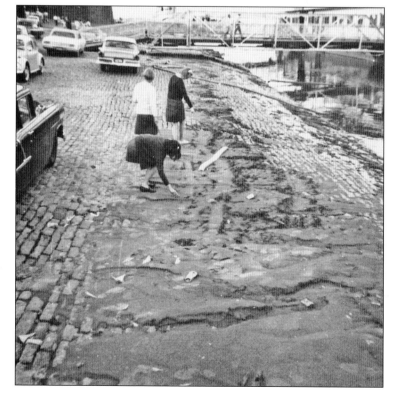

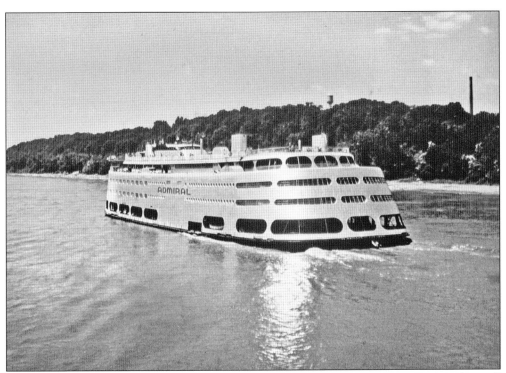

This view of the port side of the *Admiral* shows a lifeboat in its place on the first deck and a small amount of river foam coming from the side wheel. On the top deck in back are the two elevator towers and the rounded roof over the steps. There was another set of steps at the front near the pilothouse. (Capt. Jim Blum.)

Here is a partial view of the *Admiral* at night. She is still tied to the wharfboat before a moonlight trip. Through the rectangular windows, a few lights from the ballroom can be seen, and above those are the many ceiling lights on the fourth deck. On the very top is the darker pilothouse. (Capt. Jim Blum.)

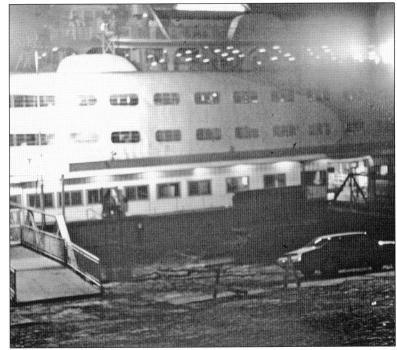

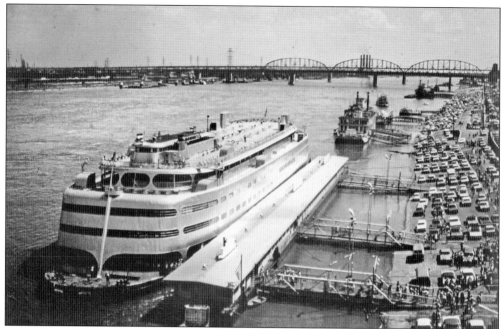

Here, the steamer *Admiral* is tied up to the wharfboat. The wharfboat was a boat in name only because it floated but had no power and was permanently in the water to serve as the offices of the Streckfus Company. Heavy parking on the levee and people on the gangplanks indicate that the boat was boarding for the day trip. (Capt. Jim Blum.)

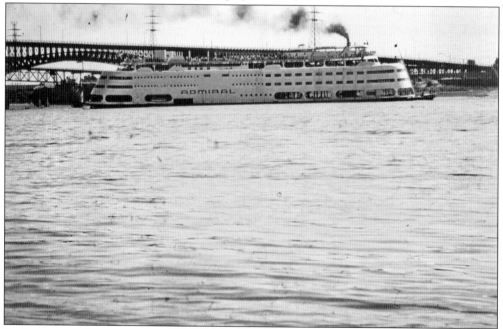

In the process of starting a day trip, the *Admiral* would make a wide turn from the wharfboat in front of the Eads Bridge before straightening out. In this picture, the boat has finished the turn and is in the process of lining up in order to steer under the next two bridges. The engines are working hard, as can be seen by the smoke pouring out of the smokestacks. (Capt. Jim Blum.)

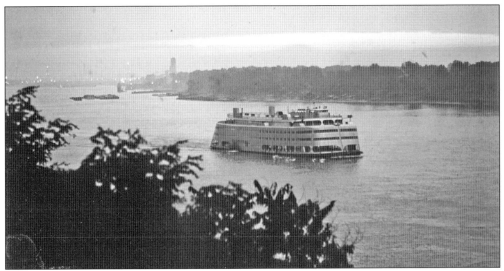

This picture shows the *Admiral* at dusk, the most quiet and lovely part of a day on the river. While almost no lights can be seen on the boat, there are twinkling lights on the shores. Directly behind the boat is the greenery of the state of Illinois, and to the left are the more industrial portions on both shores. (Capt. Jim Blum.)

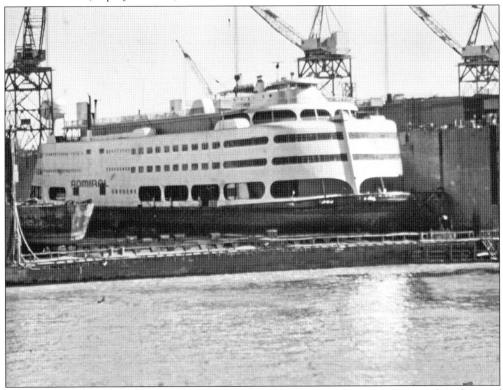

Riverboats were required to have hull inspections about every five years. The *Admiral* was of such large proportions, there was no dry dock in the St. Louis area big enough, so the boat had to be taken to New Orleans. Here, the boat has been lifted up on a dry dock, and with the help of cranes, the bottom could be inspected by the Coast Guard. (Capt. Jim Blum.)

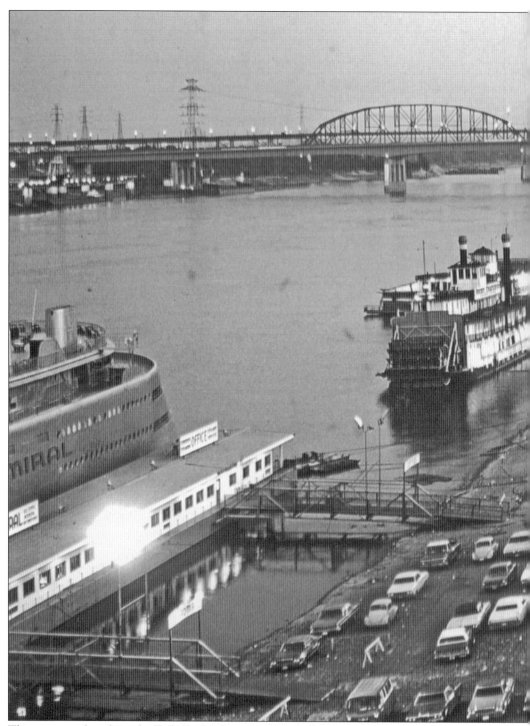

This picture taken from the Eads Bridge faces south at dusk. At right is the Leonor K. Sullivan Boulevard (Wharf Street), and at center is the levee, with a full complement of cars parked for various nighttime events. At left is the stern of the steamer *Admiral*, where lights from the cabin decks can be seen. In the back of the *Admiral* and her wharfboat are the *Becky Thatcher* restaurant

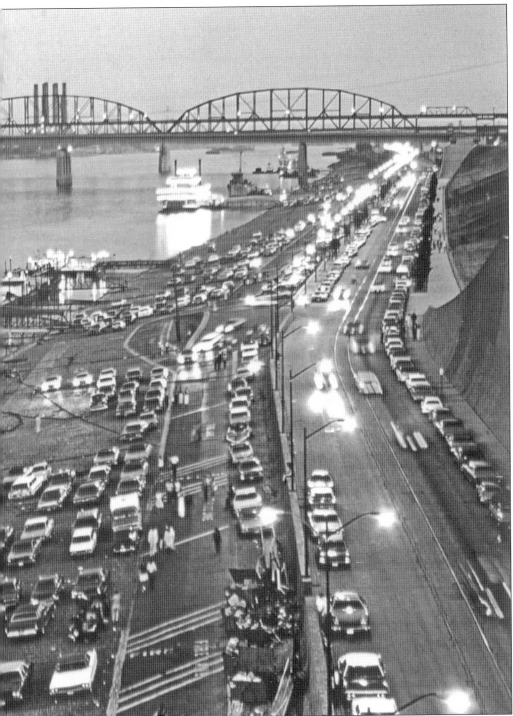

boat and the *Goldenrod* showboat. In the background is the *Lt. Robert E. Lee* restaurant boat and beyond it are the Poplar Street and MacArthur Bridges. Through the bridges, the towers of the Cahokia Power Plant can be seen. At far left is the Illinois side of the river. Through it all, the darkening Mississippi River flows south. (Capt. Jim Blum.)

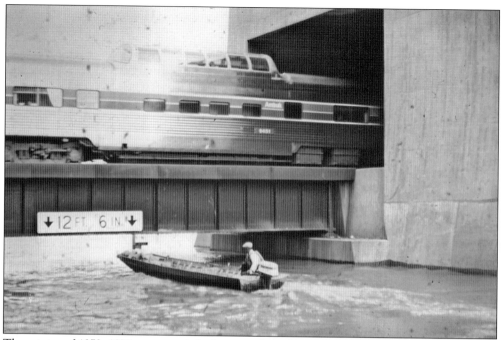

The winter of 1972–1973 was a period of extremely high water. Streckfus employees had to get to their jobs on the wharfboat by boarding a motorboat. Here, head deckhand Arthur Jackson barely makes it under the railroad bridge while an Amtrak train passes over. (Capt. Jim Blum.)

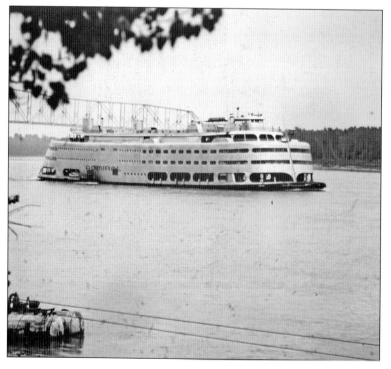

The steamer *Admiral* heads north after a day trip. She went from the Eads Bridge at 10:00 a.m., south to the Jefferson Barracks Bridge, arriving about noon, and then made the turn to start back. Until noon, there would be a commentary on the top deck so that passengers could know what they were seeing. This was a cool day, since the canvas curtains on the fourth deck are pulled close. (Capt. Jim Blum.)

Four

THE FIRST DECK

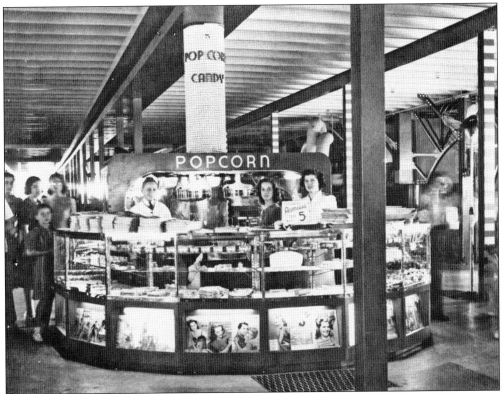

Upon entering the *Admiral*, the first attraction would be the very large popcorn and souvenir stand. When the boat started running excursions in 1940, magazines and cigars were sold here. Entertainment tastes were such that a leisurely day on the river meant passengers were onboard from 9:00 a.m. until 5:00 p.m. As ideas changed, the excursions became shorter, and the stand changed to souvenirs. The aroma of freshly popped corn made it difficult to pass by without buying.

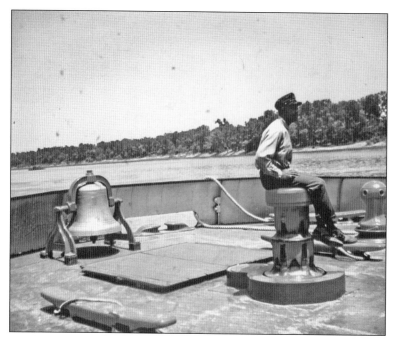

This close view of the forecastle shows head deckhand Arthur Jackson sitting on the steam powered capstan, which was the original one from the steamer *Albatross*. The capstan would turn and collect rope around it so that there was no need to move it manually. The bell is the original one, and ringing it marked lunch, starting time, and going-home time. (Capt. Jim Blum.)

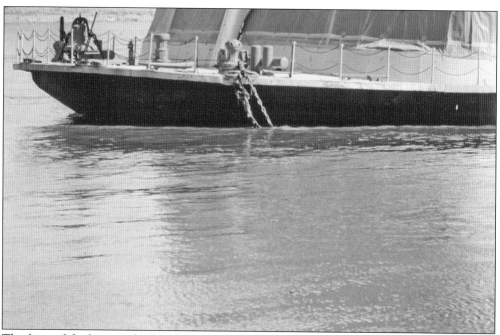

The front of the bow on the first deck is called the forecastle. In this area, the items needed for tying up the boat were stored, including the bit, chains, rope and the big ship's bell. Other such paraphernalia was stored at the stern and at midship so that the boat could be firmly attached to the wharfboat at three places. (Capt. Jim Blum.)

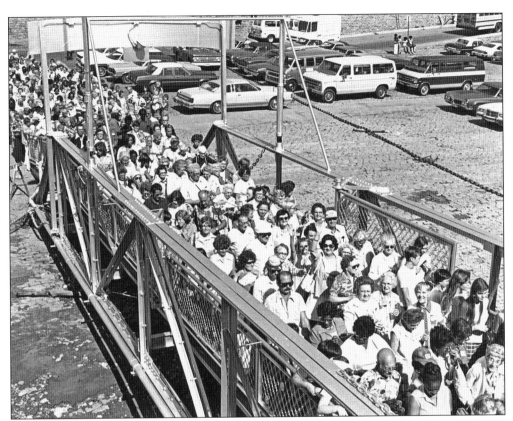

The gangplank, or stage, of the *Admiral* is jammed with people waiting for the big bell to ring so that the gates can open and they can board the boat. The boat was a popular attraction and those who got in line first had the best chance of picking a good spot to spend the day on board.

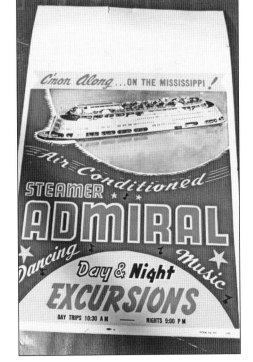

This big *Admiral* poster extols the qualities of the big boat with just a few words and a picture. In the hot, humid summers, the term "air conditioned" was magic. (Capt. Jim Blum.)

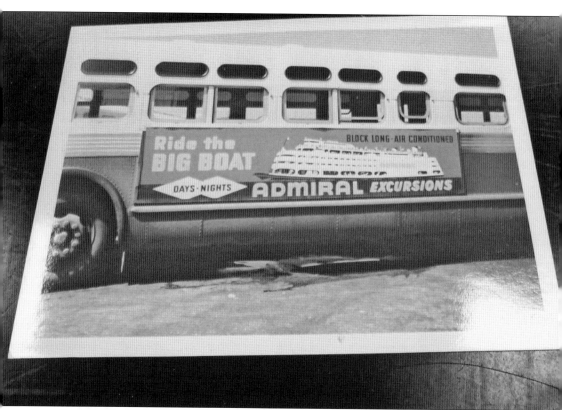

Streckfus steamers did not miss opportunities to advertise, especially since the summer season was short. In the earlier days of the *Admiral*, many people did use the bus for transportation, even at night. The bus would drop passengers off downtown, and then they would walk the three blocks to the levee.

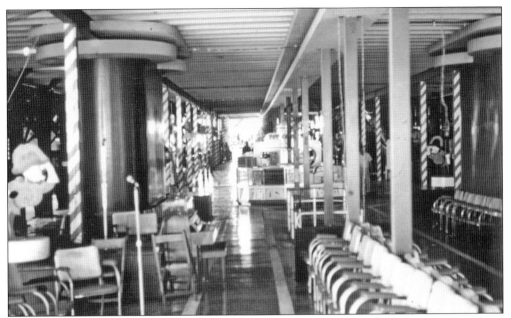

This is a long view down the middle of the first deck from the bow looking aft. These chairs were a good place to sit at the beginning of a day trip because there was a breeze when the boat was going downstream. Two of the lil Admiral statues can be seen, popular symbols of the boat itself. In the center is the popcorn and souvenir stand. The striped supports indicate areas of the arcade. (Capt. Jim Blum.)

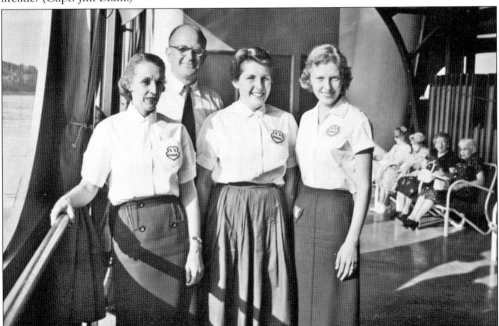

Unknown to most passengers, there were two offices on the *Admiral* on the first deck in front under the stairs. The purser's office was on the port side, where the employees counted and sorted the money from each trip. Shirley Streckfus (left), wife of Capt. John N. Streckfus, was a longtime purser. With her is Andrew Mungenast, group salesman, and two of Shirley's trustworthy clerks.

The *Admiral* was a steamboat until the winter of 1973–1974, when she was dieselized. While still a steamboat, passengers could walk through the first-deck arcade and watch the pitmen, one on each side of the boat, moving back and forth to push the sidewheels, which then moved the boat. They were painted red and white and named from characters in the Popeye cartoon. After the *Admiral* stopped running, the pitmen were put on display at the Museum of Transportation in St. Louis.

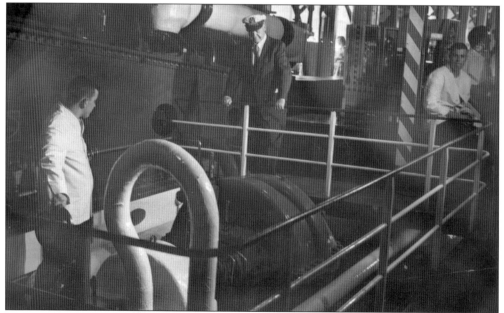

The Streckfus Steamers Company was aware that their passengers wanted the best, so they had the goal of providing the latest developments. In 1938–1940, when the *Admiral* was built, they actually thought of air conditioning two decks. At that time, air conditioning was found in very few buildings and was considered a luxury. Part of the cooling equipment could be seen on the first deck.

Below the first deck, in the hold, there was plenty of space for machinery and for storage. One important feature was the icehouse where ice was kept frozen and shoveled out as needed to take to the various stands. On weekends, additional ice would be purchased in order to have plenty.

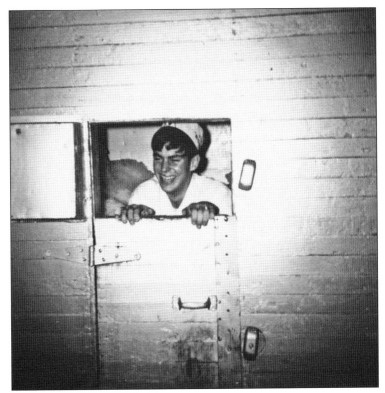

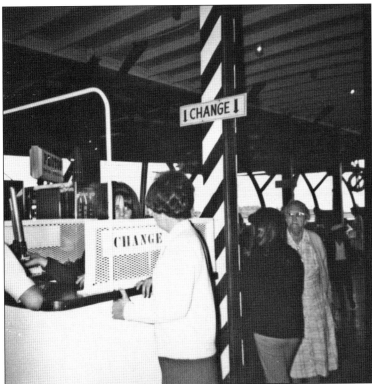

For an unknown reason, only girls were allowed to be cashiers and handle money. They had separate stands or booths. In some areas, they made change for people using the arcade machines. In other areas, the girls took payment for purchases. The only exceptions were the two souvenir stands, where the girls actually worked inside the stand, retrieved merchandize, and collected payment.

This is the hotdog/root beer stand on the first deck, where the boys have finished their preparation work and wait for the chain to drop so that passengers can board.

The root beer stand on the first deck is busy with customers. Fountain drinks and hot dogs were also available. Ice cream was sold at a stand down the deck.

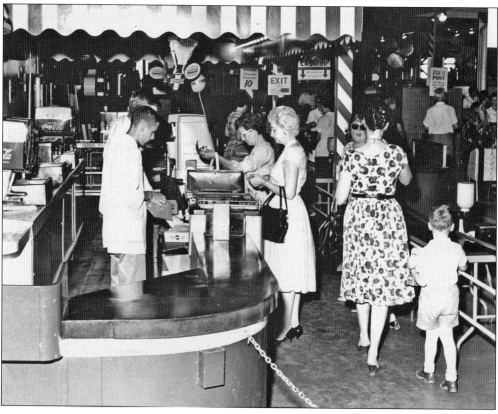

In the arcade, many varieties of games awaited passengers. The bowling machines were crowd pleasers, as were pinball, foosball, and other games.

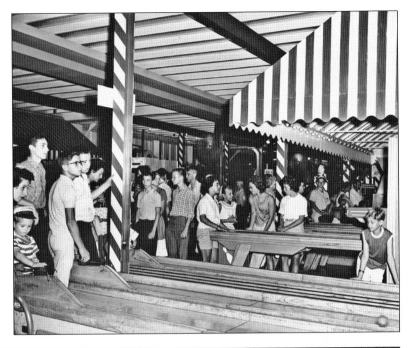

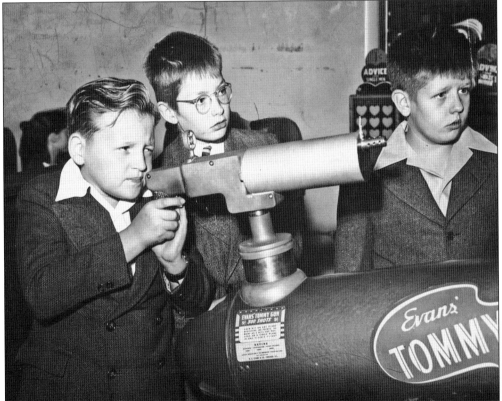

Games of skill were challenging to some, such as hitting a target or driving a race car. There were also photograph machines and voice recording devices.

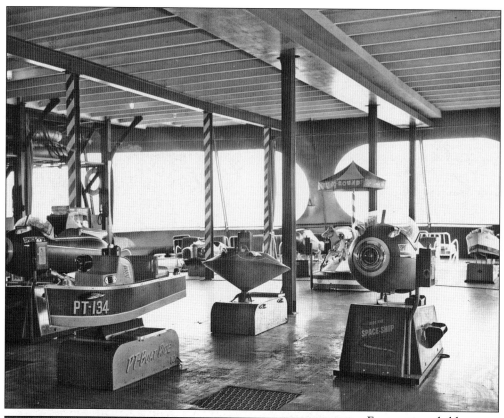

For younger children, there were simpler moving amusements, such as the boat and the space rocket. Because of the large "windows," passengers could always be aware of the river, even while busy with the arcade machines.

Some duties had to be done by the crew during every excursion trip, such as emptying the arcade machines of money, counting and recording receipts, mopping decks, and filling the cigarette machines.

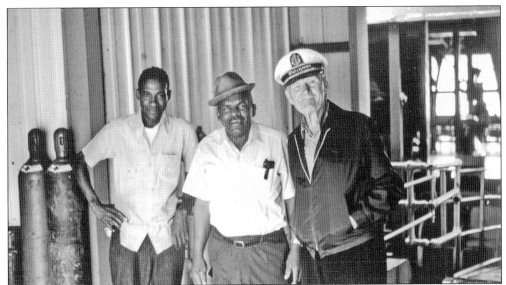

After a day cruise, three *Admiral* employees leave the boat for a short rest and some dinner before returning for the moonlight cruise. Most employees, especially those who were students, worked both trips each day of the season. These men are, from left to right, George Mister; Spencer Jones (known as "Spence" or "Daddy-O"), assistant head deckhand; and watchman Charles Henry, who was called "Dang." Dang started in the business working for the founder of the company, Capt. John Streckfus (Capt. Jim Blum.)

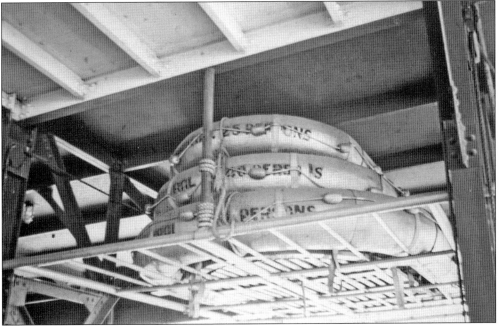

The *Admiral* was required to have Coast Guard inspections several times a year, with the largest being in the spring and fall. Like any vessel, she carried lifeboats and life jackets, enough for 400 passengers plus more for crew and some extra. One way to store life rafts was on racks close to the ceiling. They were out of the way but still visible and accessible. The writing on the sides tells how many people each raft can hold. (Capt. Jim Blum.)

Sometimes arcade games broke down, and that meant calling an "arcade boy." Kids would hover around while he unlocked it to see if he could repair it. If so, the game was locked up again and play could go on. The worse scenario was when the arcade boy had to put a piece of tape over the money slot, indicating that an expert would have to be called.

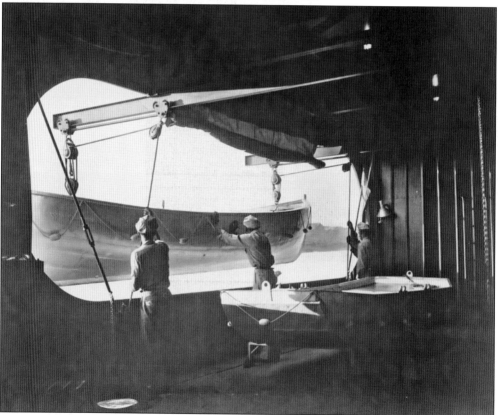

At each side of the back of the first deck was an area called the boat deck. Here, the lifeboats were attached to lifts on hoists so that they could be easily lowered into the water.

The *Admiral* had a mascot known as the lil Admiral. This small cutout on a round base greeted passengers in his formal captain's uniform with white gloves and plumed hat. One of these mascots now makes his home at Mercantile Library in St. Louis.

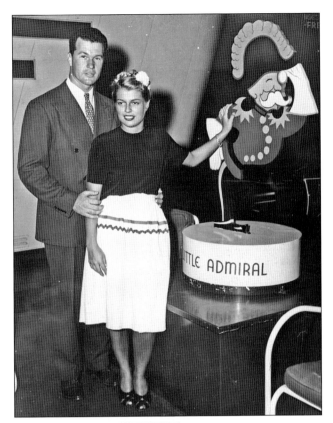

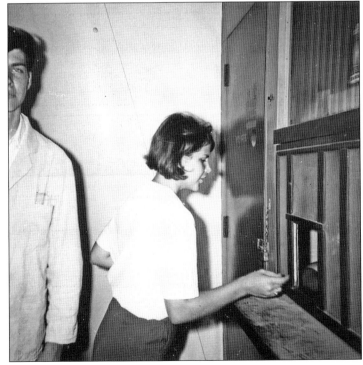

On the starboard side of the boat, under the steps, was another office. Beyond the door was office space for the captain and staff. Passengers and crew could conduct business using this small window.

A deckhand gathers rope around a cavel (a holding device) during the process of landing the *Admiral*. The lines had to be firmly attached but not so tight as to cause friction.

This is another area in the hold below the first deck used for storage of supplies for the various stands. The storekeeper also used this area to mix root beer for the boat.

A boat's officer stands in an equipment room in the hold. An outstanding feature of the *Admiral* was that, as much as possible, the machinery was in the hold, out of sight. In that way, room was made for the stands and arcade on the first deck.

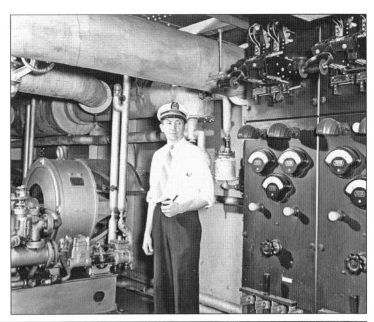

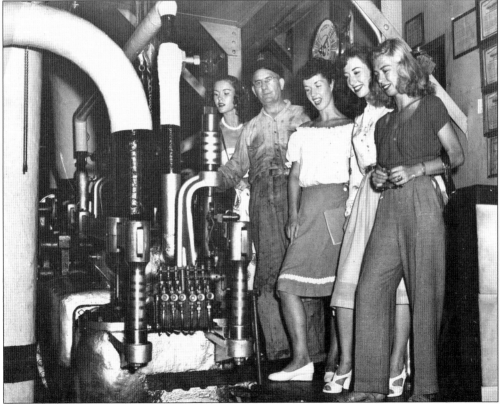

Since the *Admiral* was a side-wheeler, there was an engineer's station on each side of the first deck. Chief engineer Jack Chapman shows the port-side station to some visitors. The round indicator behind him is a way to communicate with the pilot on the top deck. On the right, the licenses of crew are proudly displayed.

When the steamer *Admiral* first opened in 1940, this stand on the first deck sold chocolate milk for 50¢. The support poles were striped, and in the back to the right is the starboard pitman doing its job of pushing the unseen sidewheel.

The steam driven generator was housed in the hold. It produced direct current electricity. After the boat was dieselized in 1973, all the electricity produced was alternating current.

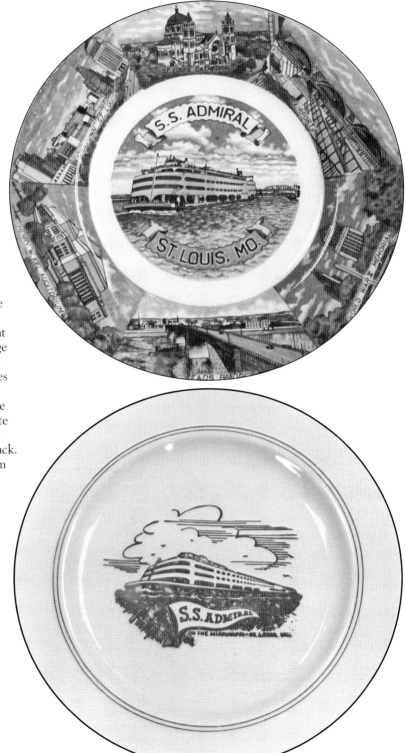

Many of the souvenirs sold in the *Admiral* are now collectors' items. The plate at top with the image of the boat in the center had pictures of other St. Louis spots in color. The other plate is white with a drawing of the *Admiral* in black. It is an earlier item and is considered a more desirable souvenir.

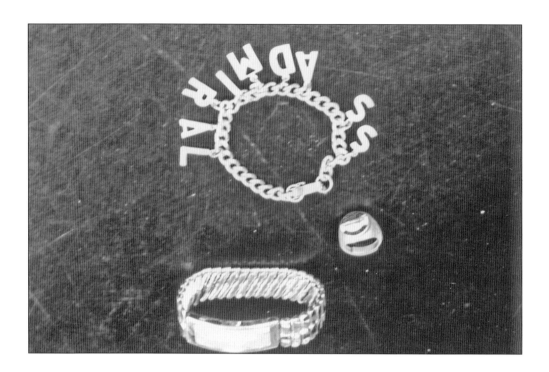

Jewelry was a good item to sell when there were teenagers on board. The expandable bracelet above has a multicolor enamel picture of the *Admiral*, as does the ring. The bracelet has letter charms spelling out the name of the boat. With all three, the base color was gold. Below, the dish sides had an open design in a copper color, and the outline of the *Admiral* was in silver.

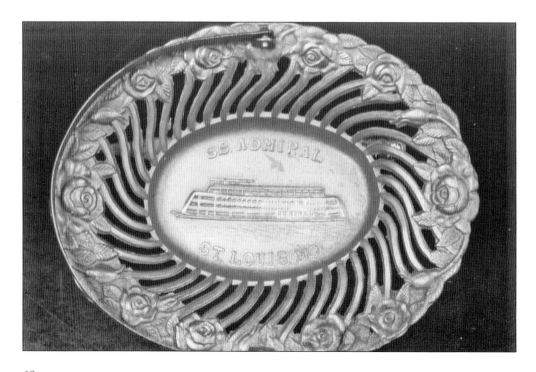

Every year, an agent from a company in New York City would make a selling trip around the middle and eastern United States. Items with the name of the boat and/or with the design would be ordered from him. The copper-colored basket above had the *Admiral* design in the center and a handle. The little tea set below was quite popular.

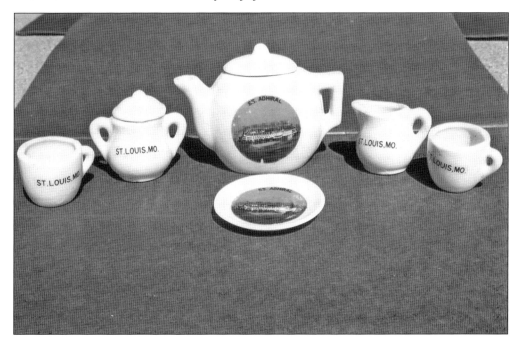

While some items were only available for a few years and then disappeared, pennants were always good souvenirs. The game and the pocket knife below were very inexpensive and sold best at the end of the ride when children were looking for something to buy with their last few cents.

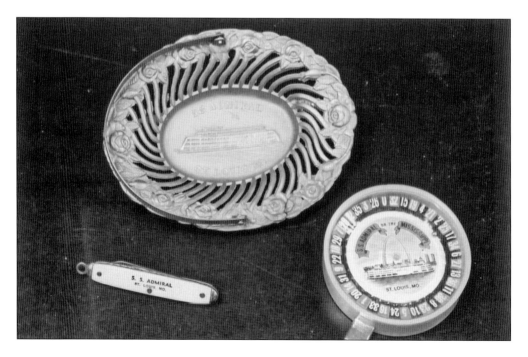

Five

THE CABIN

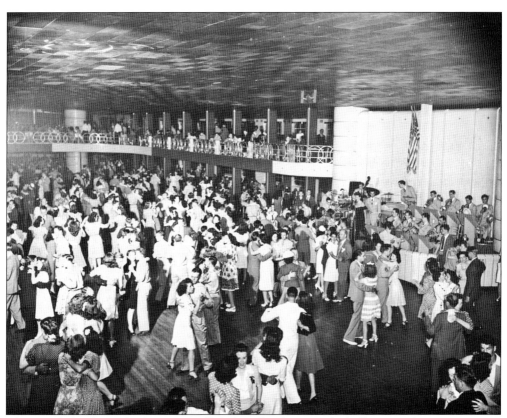

The two decks above the first were called the cabin because the ballroom and mezzanine were together in air-conditioned comfort. When the *Admiral* opened in 1940, the signs of the zodiac were painted on the ceiling.

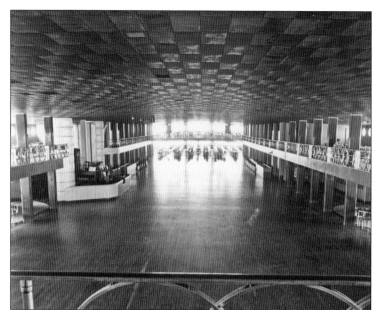

The *Admiral* held 4,000 passengers plus crew, and the ballroom could hold 2,000 of those. The design and the furnishings continued the Art Deco design.

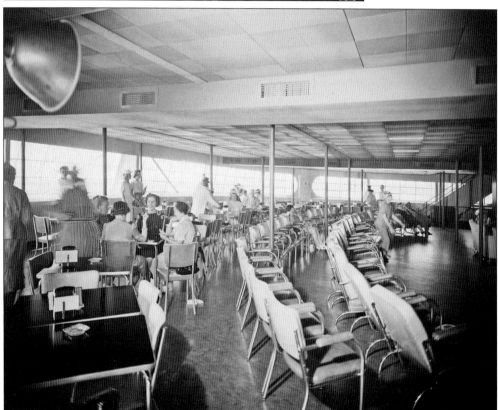

This is a section of the mezzanine, giving a feeling of the sweep of the large windows and the airiness of the space. The supports are narrow so as not to impede the views. Waiters move among the Art Deco tables and the whole effect is one of comfort. (The State Historical Society of Missouri Photograph Collection.)

There was a souvenir stand on the port side of the ballroom opposite the bandstand. The sailor and captain hats were popular items in addition to whistles, magnets, pens, and other objects marked with the *Admiral* name.

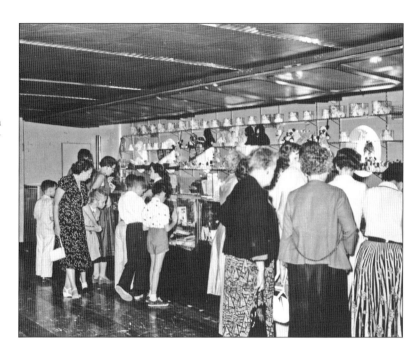

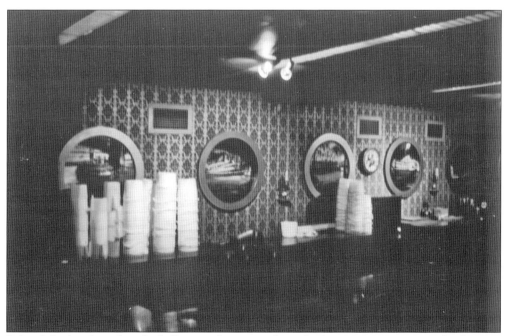

Behind the bandstand in the ballroom, there was a bar, which was very convenient for dancers. On the back wall were paintings depicting the old Streckfus wooden boats. These pictures are now mounted on the walls of the Pott Inland Rivers Library as part of the St. Louis Mercantile Library. (Capt. Jim Blum.)

Here is a closer look at one of the pictures on the wall of the ballroom bar. Passengers could buy beer or mixed drinks or bring a bottle of liquor and buy setups. The white containers on the left were used for ice. At the top left is a vent for the air conditioning. (Capt. Jim Blum.)

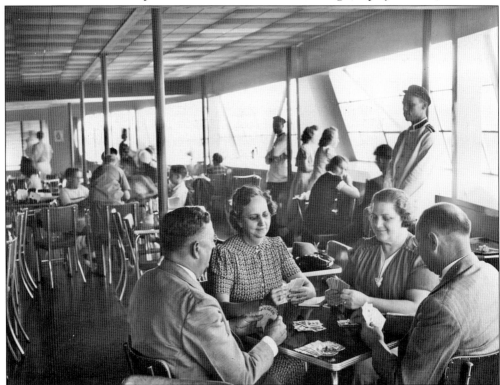

Card and board game groups were popular, especially in the coolness of the cabin. Here, people could also dream, nap, view the river, or read while listening to the music of a live band.

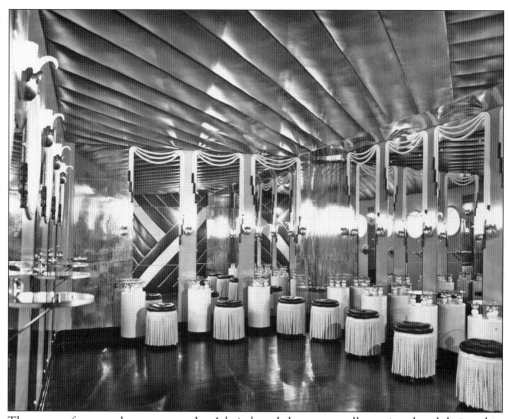

There were four powder rooms on the *Admiral*, and they were well appointed and designed in order with the rest of the boat's Art Deco styling. The Glamour powder room was created to look like the dressing room of a Hollywood movie star.

Three of the powder rooms were named for popular stars in the early 1940s, and the names were not changed. The Sonja power room was for Sonja Henie, the skating star. All the rooms had maids to assist as needed.

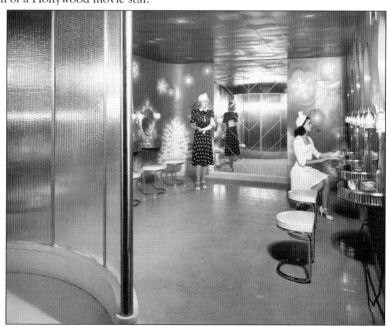

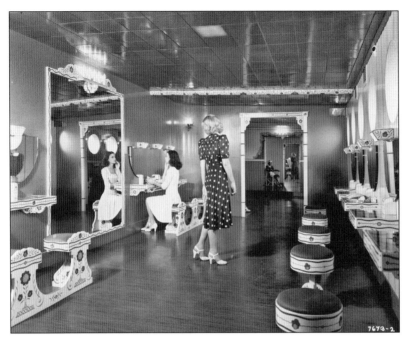

The Greta powder room was on the mezzanine and was reminiscent of the home country of Swedish star Greta Garbo.

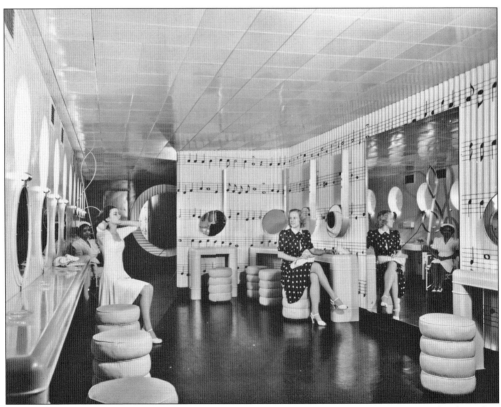

The Deanna powder room was named for Deanna Durbin, the singing movie star. Like the other powder rooms, there was one big space with mirrors and stools for primping.

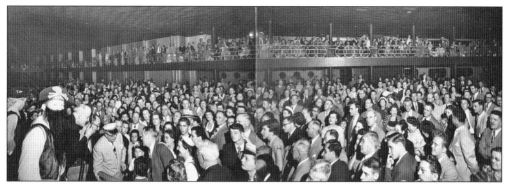

The most fun at night was probably in the ballroom. There were tables and chairs, a bar, waiter service, a live multi-piece band, and a mezzanine.

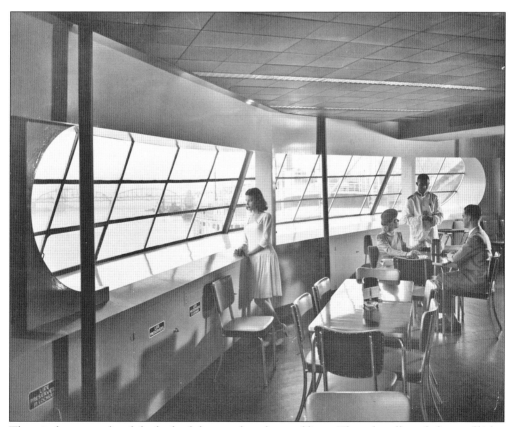

The windows completed the look of clean and uncluttered lines. They also allowed plenty of light. A passenger could not miss the outside river activities, even while dancing.

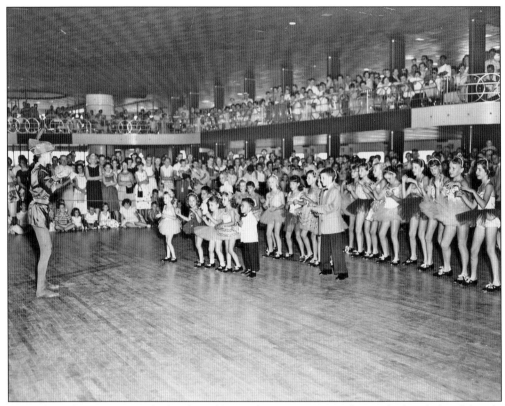

Every day, a dance or musical school would provide entertainment during the band's lunch break. These shows were enjoyed by the passengers and gave the schools a chance to earn funds using group rates.

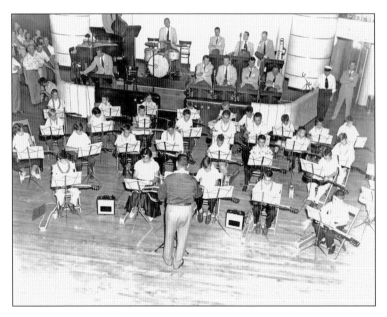

On most excursions, the lunchtime entertainment was provided by a dance school. Other performances included pompom teams, kitchen bands, and orchestras. Nervousness seemed to help them perform to their best ability.

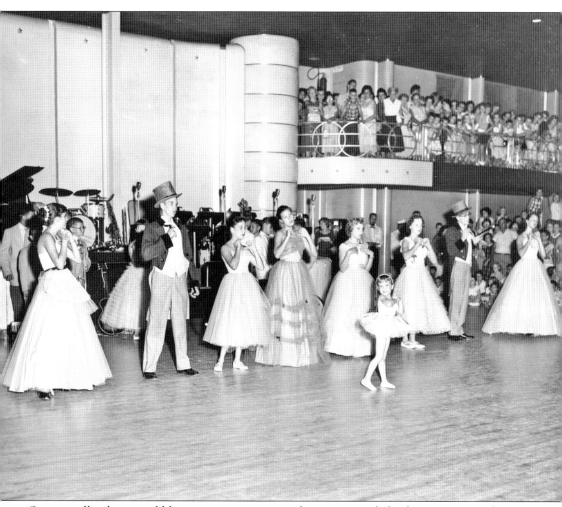

Occasionally, there would be extra entertainment during a moonlight dance cruise, such as a beauty contest, the crowning of a prom queen, or a guest musical group.

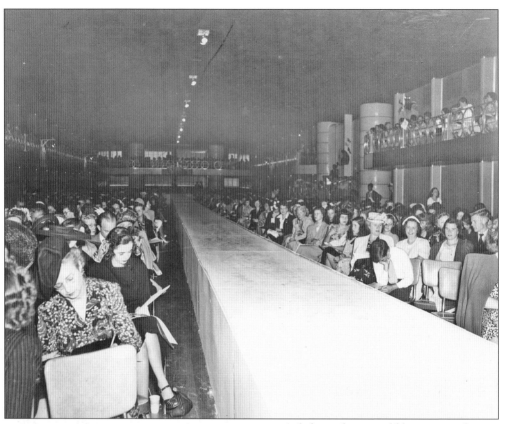

A fashion show would be presented in the ballroom once or twice a season. This would take place after the day trip. The fashions came from one or two local shops, which would also provide the announcer.

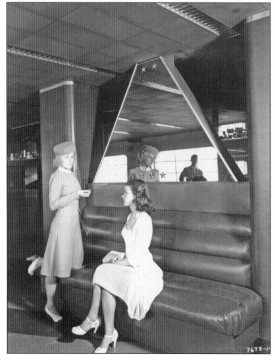

A sophisticated corner of the mezzanine featured built-in cushioned chairs—part of the Art Deco design. Streckfus sometimes used models to demonstrate how to dress; in this case, for a night excursion. The company wanted to maintain the high reputation of their operation.

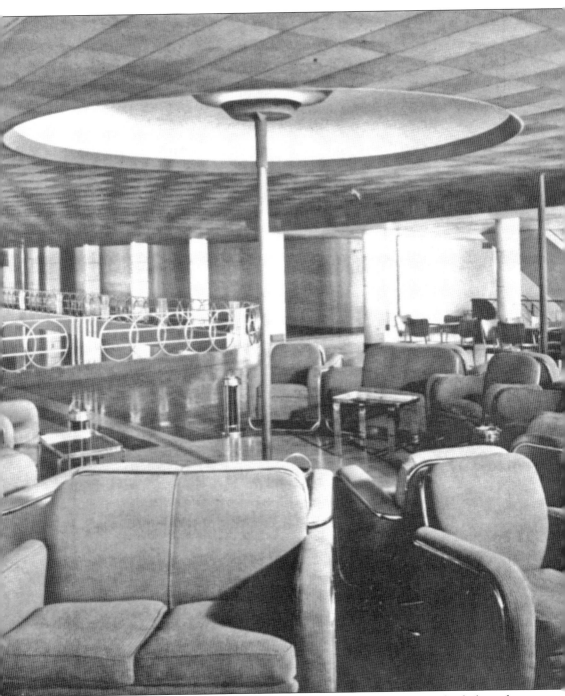

Another sophisticated place, the Club Admiral area, located in the mezzanine, used upholstered furniture and a domed decoration in the ceiling.

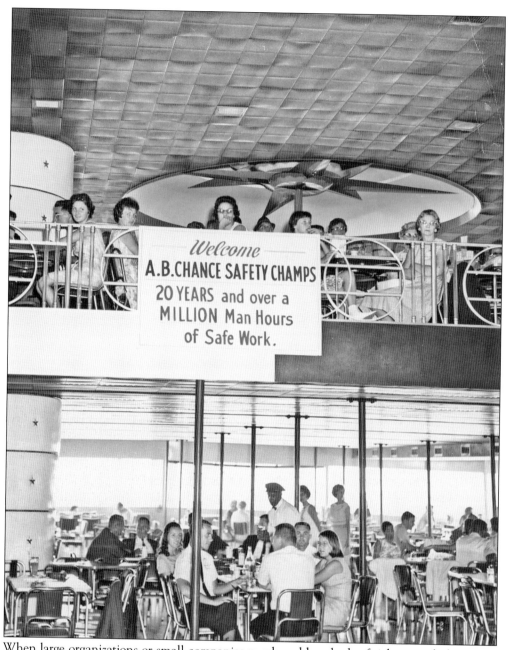

Welcome
A.B.CHANCE SAFETY CHAMPS
20 YEARS and over a
MILLION Man Hours
of Safe Work.

When large organizations or small companies purchased hundreds of tickets, a whole section of the *Admiral* could be reserved. Here, a company has taken over the Club Admiral area and posted its own welcome sign.

Six

THE FOURTH DECK

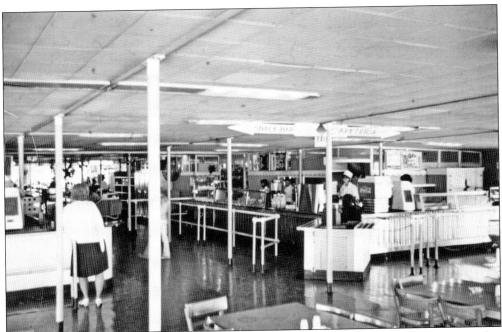

This view of the fourth deck from midship looks aft. This deck was roofed with open sides, providing shade and ventilation. On the left, one edge of the snack bar can be seen, while the double-edged cafeteria is on the right. Also on this deck were the main kitchen, bar, and dishroom. (Capt. Jim Blum.)

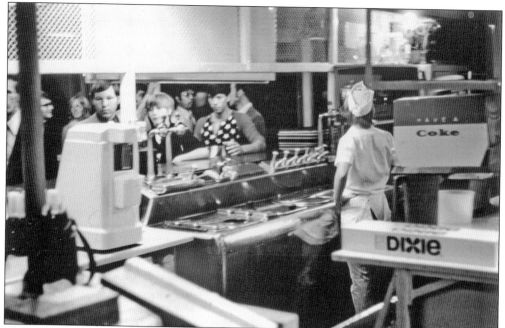

This is a view of the inside of the fourth-deck soda fountain at midship. The soda jerk would make ice-cream sodas and sundaes as well as fresh sandwiches. Canned and fountain drinks were also available. The young workers were mostly high school students earning money for school. (Capt. Jim Blum.)

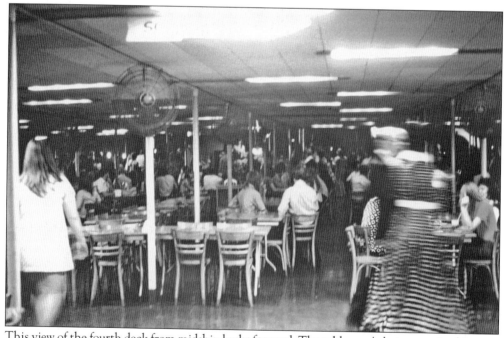

This view of the fourth deck from midship looks forward. The tables and chairs were in this area. Passengers could bring their lunches from home and sit wherever they wanted on the boat, go to this deck and buy food directly from a food stand, or be served by a waiter. (Capt. Jim Blum.)

The waiters used simple menus like this one. After accepting the order, the waiter would go to the main kitchen for the food and pay for it. After serving the table, the customer would pay the waiter. This particular menu is marked "gratis" because it was food ordered by the engine-room department.

C	Nº 9718	AMOUNT	500

WAITER ___ Eng ___ $

WAITER PRESENTS THIS CHECK TO PATRON WHEN SERVED

STRECKFUS STEAMERS AUG 1 1960

WAITER ___ Eng ___ SS. ADMIRAL — MOONLIGHT DATE

C	Nº 9718	DECK

NO.	ITEM	EA.	TOTAL	NO.	ITEM	EA.	TOTAL
	OF Roast Beef and Potatoes	1.05			Swiss Cheese	.60	45
	De Luxe Hamburger	1.05			Hot Fish	.65	
	Ham & Cheese Combination	.95			Egg Salad Ham Salad	.60	
	Cheeseburger	.90			Am. Cheese	.55	
1	Hamburger	.80	5 0		Peanut Butter Braunschw.	.55	
3	Ham	.75		2	Frankfurter	.45	40
2	BB Beef Roast Beef	.80	120		French Fries	.30	
	Ice Cream	.40			Pie	.45	
	Ice Cr. Soda	.55			Pie-A-la-mode	.60	
	Sundaes	.55			Tomato Juice	.25	
5	Milk—White Choc.	.25	5 0		Tea Coffee	.25	
	Fresh Fruit Orangeade	.55		3	Coke—Rt. Beer Soda—Gin. Ale	.30	30
	Beer—Local	.45			Bourbon Hi	.80	
	Beer—Prem.	.50			Bourbon BB	.90	
	Cocktails	.80			Scotch	.90	
	Large Soda— Kola—Gin. Ale	.90			Sliced Lemon or Lime	.30	
	Spark. Water	.90			Setup of Soda Glasses and Ice	1.80	
	2-Quart Pitcher Water	.90			Lg. Bowl Ice	.90	
	Popcorn (Med.)	.25			Popcorn (Lg.)	.35	

30M-5-67-K.

Pay Waiter this Amount — TOTAL Jack

Some tables overlooked the river, providing a pleasant place to sit. The canvas curtain is bunched and tied back, but in the case of wind or rain, it could easily be closed to help protect the passengers.

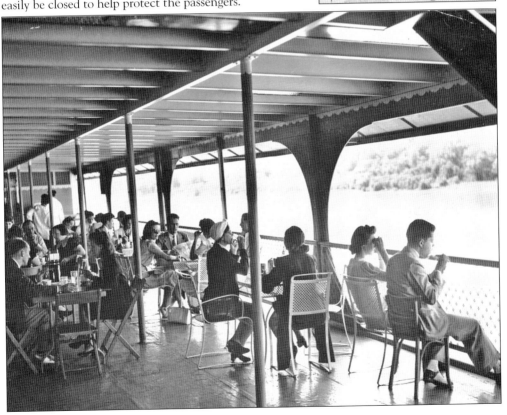

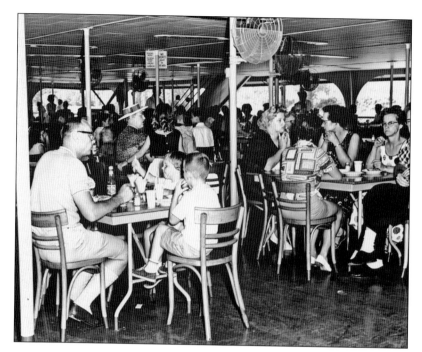

More than enough tables and chairs were placed at the bow and stern of the fourth deck. The stairs in the background lead to the top deck.

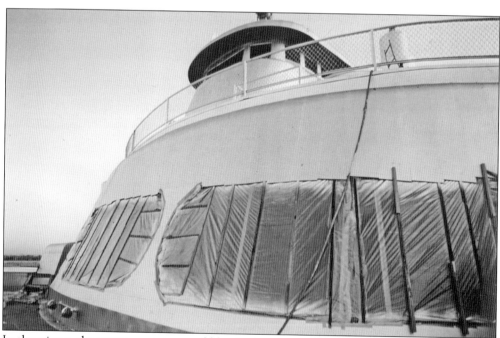

In the winter, the canvas curtains would be drawn across at each opening, and on the outside, heavy plastic would be taped down in an effort to keep wind from howling through. Inside, the workers, wearing heavy winter work clothes, would go about the jobs of cleaning and important repairs. In the spring, it was time for painting. Contrary to common belief, the *Admiral* did not leave St. Louis in the winter. (Capt. Jim Blum.)

Lucy Foster (left) and Effie Goss, two of the *Admiral* cooks, eat their own lunch after finally taking care of preparing food for crew and passengers. They cooked delicious food in generous portions.

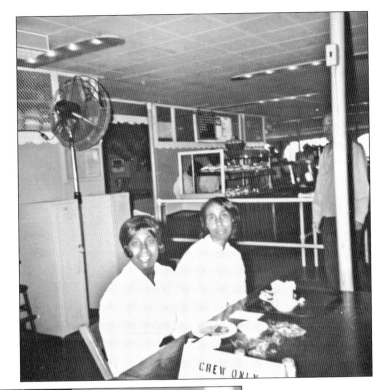

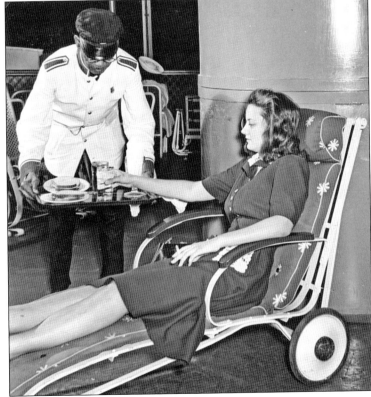

Comfortable deck chairs were in the bow of the fourth deck. Here, a passenger is receiving lunch from a waiter.

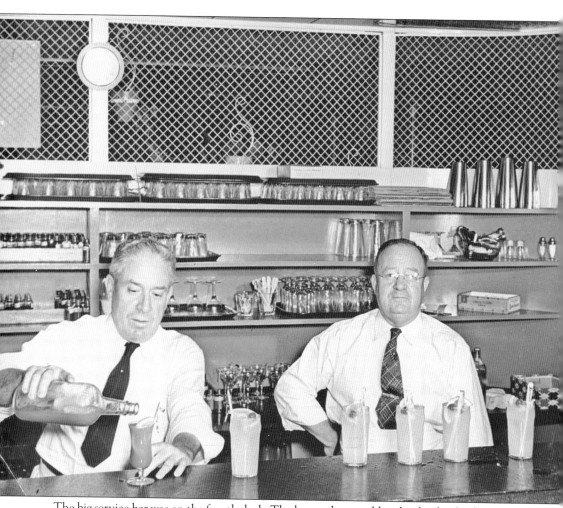

The big service bar was on the fourth deck. The bartenders would make the drinks that the waiters served. On the other side of the wall was a walk-up bar for those preferring not to call a waiter.

Seven

THE TOP DECK

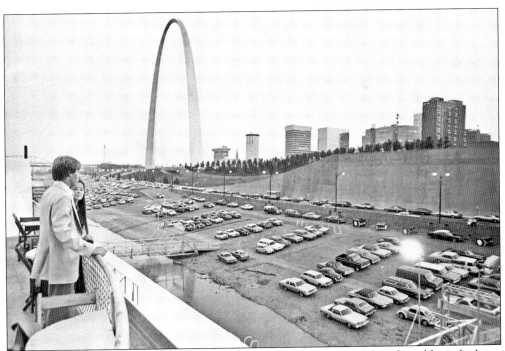

A passenger overlooking the levee from the top deck of the steamer *Admiral* would see the levee and the completed Gateway Arch in the Jefferson National Expansion Memorial Park. The top deck was also called the roof, or lido deck.

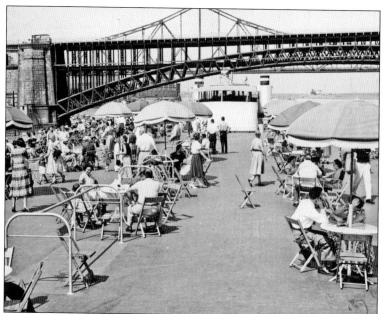

Passengers sit under the big umbrellas with the Eads and Martin Luther King Bridges in view. For many people, the top deck was the first stop after entering the *Admiral*.

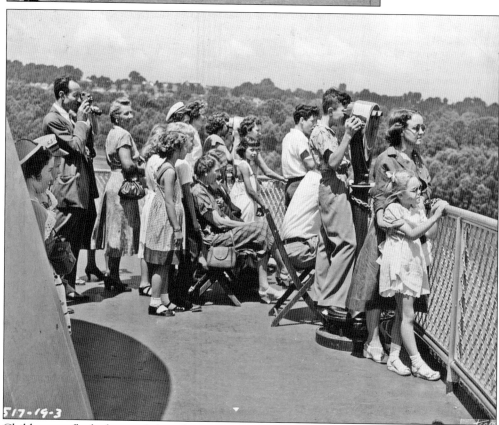

Children are flocked around the telescopes waiting for a turn. The telescopes were promoted as being the same type used on the Empire State Building in New York City. Putting a dime in the slot provided a good view of distant points.

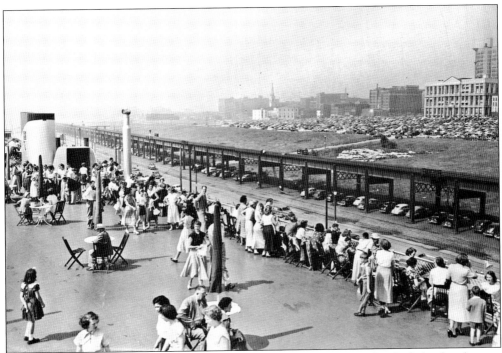

Passengers pause for a view of St. Louis from the river. In the back is the shaft for the elevator, and lower down is the rounded cover over the steps.

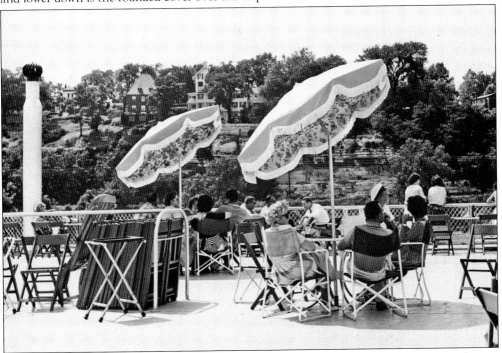

Here, the *Admiral* passes an area of St. Louis known as Chouteau's Bluffs. There were large houses and retirement homes on the bluff, and at night, some of the homes would flash their outdoor lights as the *Admiral* passed.

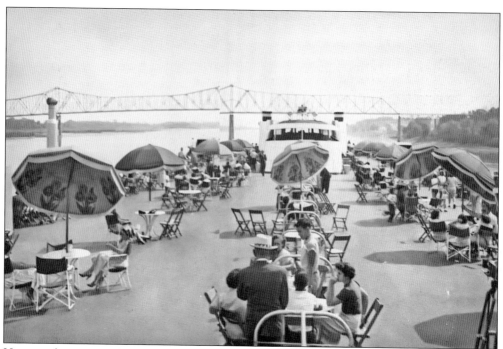

Here is a long view of the top deck facing forward as the big boat prepares to pass under the Jefferson Barracks Bridge. This was the southern limit to the excursion; the boat would turn shortly after passing under the bridge.

Chairs were placed alongside the pilothouse in the shade. To the right is the calliope and aft, the exhaust pole and the elevator shaft.

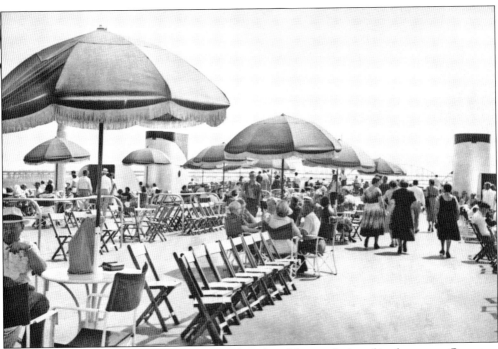

Deck chairs and umbrellas were placed along the sides of the top deck and in the center. On extra-hot days, passengers would leave the open deck by noon and head for the cooler lower decks.

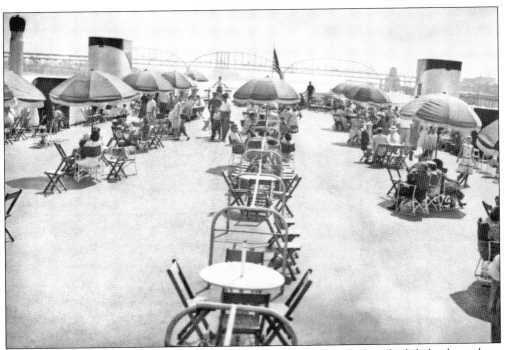

There was a narrative that could be heard on the top and fourth decks, which helped people to identify the sights on shore. This lasted until noon or until the turn was made.

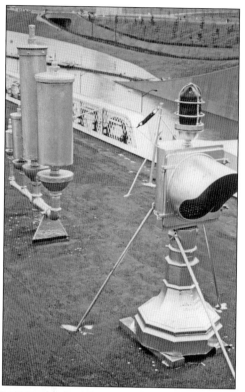

The steam whistles and the lights were housed on the lido deck. The four-tone whistle was used before leaving the dock and before landing. Whistles also played a part in communicating with other boats while passing in the river, especially before marine radios. By law, the whistle had to display a light while blowing. Each boat had its own landing whistle; the *Admiral's* was one long blast, followed by two short blasts and one long. (Capt. Jim Blum.)

The design of the *Admiral* followed the Art Deco plan outside and inside. Interior designer Mazie Krebs drew the gigantic letters for this sign outside the pilot house Texas. They were lit at night with neon. The Texas contained a few bedrooms and showers for out-of-town family members. A round window marked each room. (Capt. Jim Blum.)

Capt. William Carroll is pictured on the port-side flying bridge, which extended out, making it easier to land or tie up the boat. The control panel enabled him to gently land the boat alongside the wharfboat. This arrangement was made after the boat was dieselized in 1973. Prior to that, the boat was run by steam, and the captain would land the boat by radioing instructions to the pilot inside the pilothouse. (Capt. Jim Blum.)

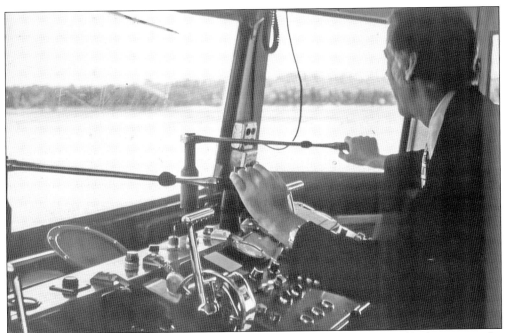

Capt. William Carroll, master of the *Admiral*, is steering during a day trip and looking out at the Illinois side. The big windows gave a good view. This is how the controls looked after the boat had been changed from steam to diesel power. The long levers moved the rudders left or right, and the shorter lever controlled the power. Also, there were controls for light and the whistle, and an onboard telephone. (Capt. Jim Blum.)

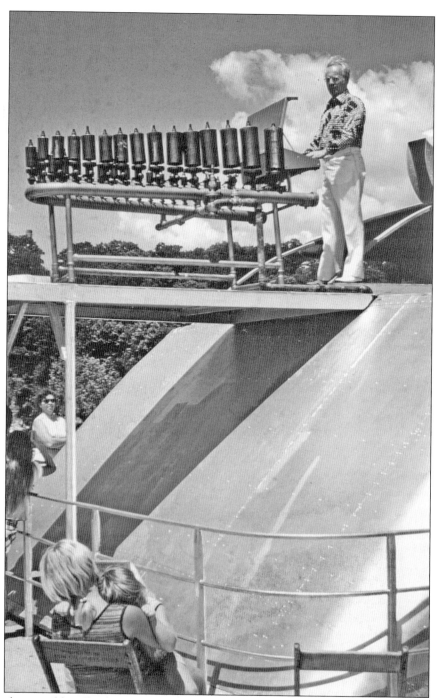

Piano player and bandleader Dick Renna prepares to play the calliope on the top deck of the *Admiral*. A calliope is also known as a steam "pianni." It is a collection of pipes, whistles, and a keyboard. The steam would go into the pipes, and pressing a key would force steam through a certain whistle, creating a tone. The keys were hard to press, and steam poured out of the pipes the whole time while playing. It is a very loud instrument and can be heard over a long distance. (Capt. Jim Blum.)

The most comfortable place to sit on the whole boat was in the pilothouse on the lazy back bench. From here, a person had a view of river, sky, and land. The stairwell and door on the left lead to the outside deck. Capt. Bill Streckfus sits on the bench, keeping the pilot company. Captain Bill is the son of Capt. Roy Streckfus (one of the Commodore's sons) and represents the third generation of Streckfus steamboating.

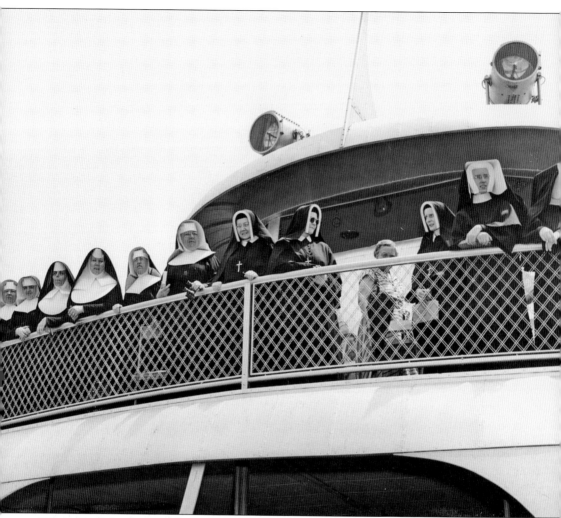

When Streckfus Steamers learned that 200 or more nuns from around the United States were going to attend a multi-day meeting at St. Louis University, the company invited the sisters to be their guests onboard. Most of them attended and seemed to enjoy the view from the top deck.

Eight

STAGES OF LIFE

The *Admiral* was built on the hull and machinery of the former sidewheel railroad transfer boat *Albatross*, constructed in 1907 at Dubuque, Iowa. She had two wheels: one on the port side and the other on the starboard side. The port wheel shaft's outer A-frame shows the outer-end shaft and bearing support. This gives an idea of the parts that were removed in 1973, when Streckfus Steamers decided to remove the steam equipment and replace it with diesel power.

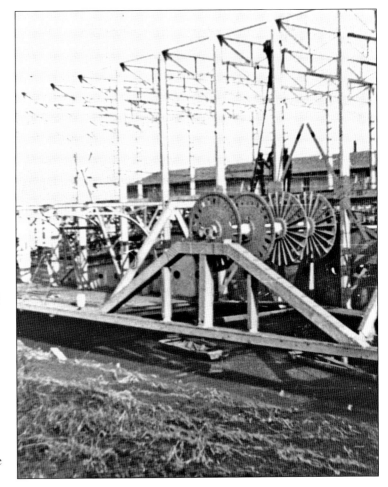

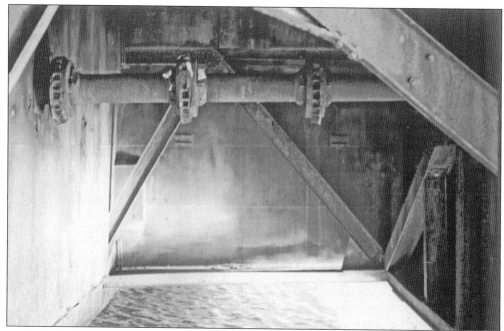

The shaft that held the paddlewheel was cut into pieces in order to get it out. The whole procedure was a tremendous undertaking over the winter of 1973–1974. (Capt. Jim Blum.)

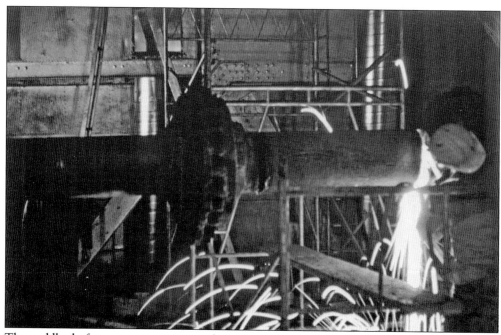

The paddle shafts were cut into pieces for removal. New diesel propulsion units were put into both port and starboard paddlewheel boxes. (Capt. Jim Blum.)

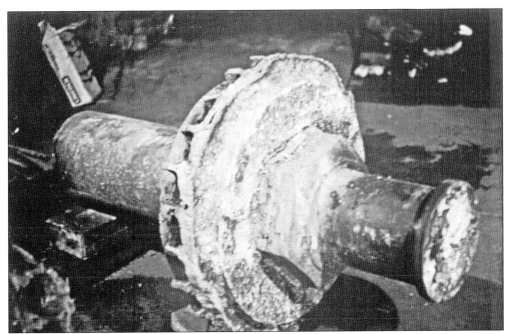

This is a closer view of one of the paddlewheel shafts. It was cut out of the brass bearing it rode in. (Capt. Jim Blum.)

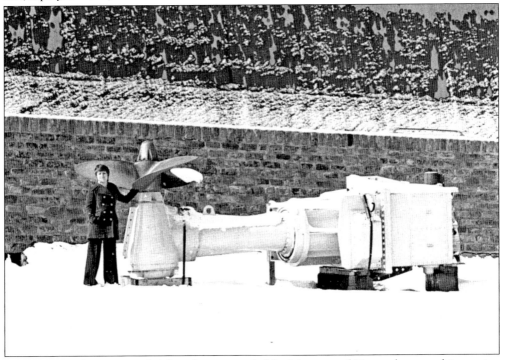

Power to run the converted *Admiral* was provided by Murray and Tregurtha propulsion units. Each unit was equipped with a six-foot diameter propeller, capable of rotating 350 degrees, and could be raised out of the water if it needed service. The office girl in the picture gives an idea of the unit's huge size.

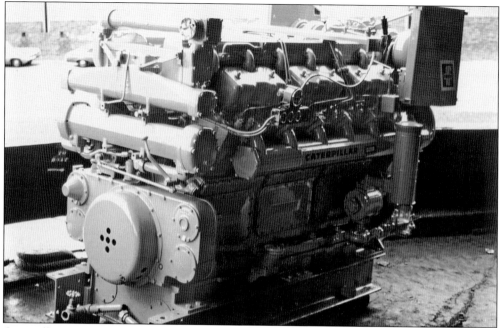

Caterpillar engines ran the Murray and Tregurtha units and the new generators. The Fabick Company of Fenton, Missouri, supplied the engines. (Capt. Jim Blum.)

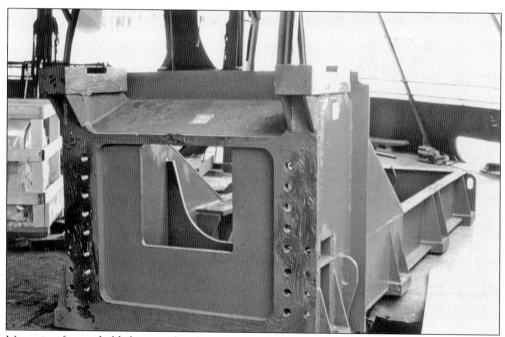

Mounting frames held the new diesel engines in place within the old paddlewheel boxes. The Murray and Tregurtha units were anchored to the forward part while the Caterpillar diesel was bolted to the back. (Capt. Jim Blum.)

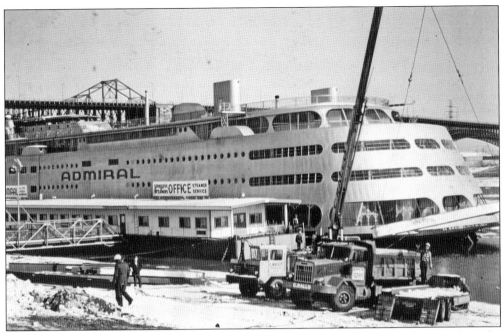

Outside, with snow on the ground, equipment and workers prepare for another day's work on the *Admiral* diesel conversion project. The *Admiral* continued to run as an excursion boat through 1978. She was sold in 1981. (Capt. Jim Blum.)

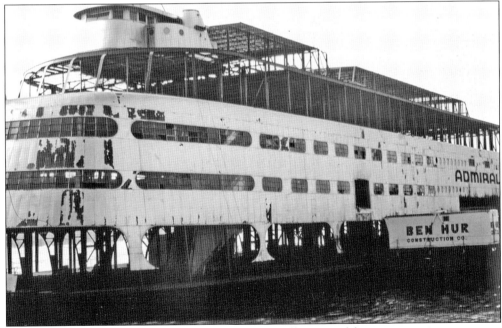

In the 1980s, two efforts to make the *Admiral* financially successful as an entertainment center were attempted. The name used was SS *Admiral*. After some years of neglect, the first step was to make some structural changes. The fourth deck was completely closed in, and on the top deck, the Texas was removed, and a closed deck was added. (Capt. Jim Blum.)

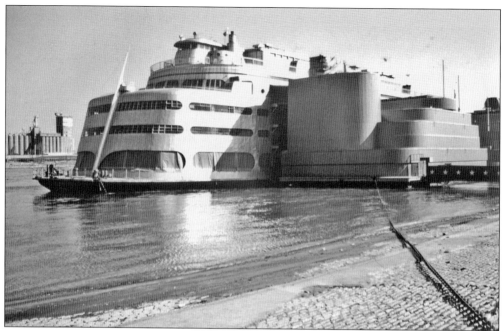

An addition was made to the port side of the *Admiral* for use as a theater. The whole outside of the boat was painted silver, and the addition was painted pink. (Capt. Jim Blum.)

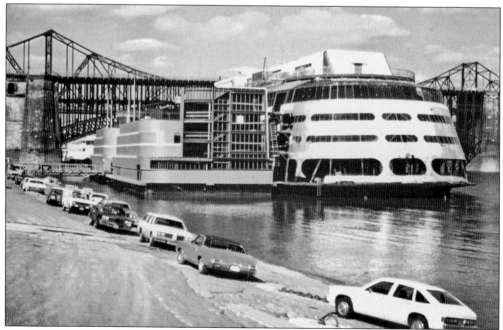

The new portion of the entertainment SS *Admiral* contained additional exits from the various decks. They can be seen from this side view. (Capt. Jim Blum.)

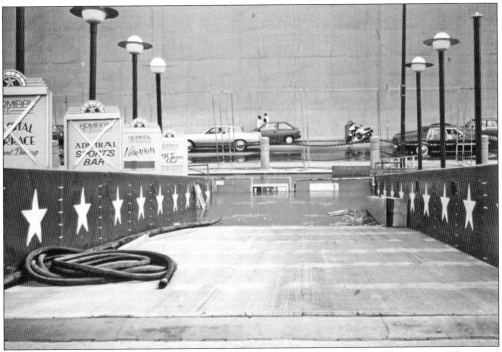

The entrance to the entertainment center SS *Admiral* is pictured in high water. The signs indicate a restaurant, a sports bar, and other venues. The tops of the signs read SS *Admiral*. (Capt. Jim Blum.)

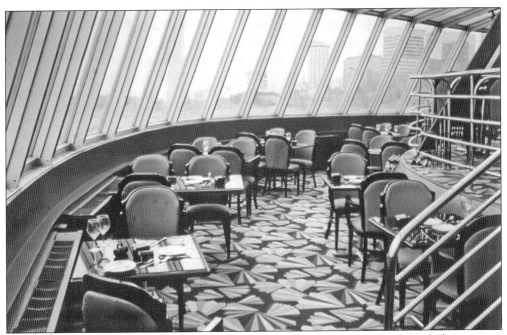

Most of the fourth deck and promenade area was enclosed, and the back of the deck was given new windows and refurbished to become the rather elegant Crystal Terrace Restaurant. (Capt. Jim Blum.)

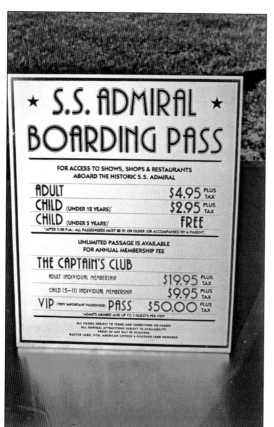

This boarding pass gave the prices to enter the entertainment center. The price did not include food, bar, and other purchases. (Capt. Jim Blum.)

The cocktail napkins carried a new design that evoked memories of when the *Admiral* was really a boat. (Capt. Jim Blum.)

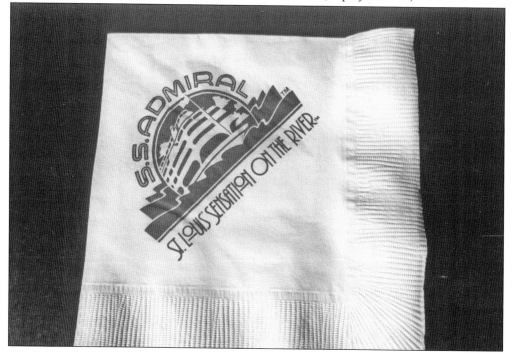

At the stern of the old promenade section of the fourth deck, there was a sitting room adjacent to the Crystal Terrace Restaurant. The doors with the round windows greatly resembled the original door leading from the mezzanine to the fourth deck. (Capt. Jim Blum.)

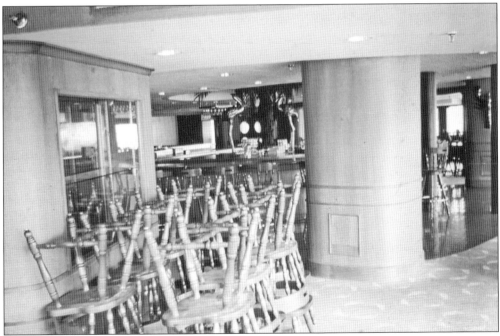

A seafood restaurant was located on the mezzanine in an area that had a dome decoration and was called Club Admiral. The new owners kept the dome and built a bar as part of the eating establishment. (Capt. Jim Blum.)

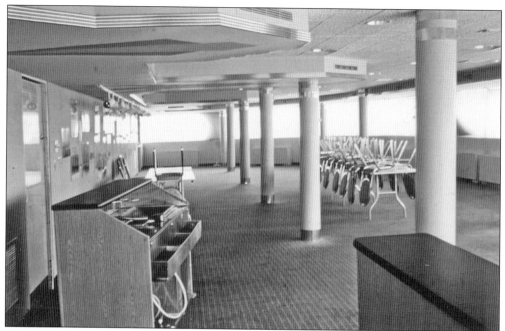

The stern portion of the old ballroom deck was walled off to be used for private parties. The windows look about the same as they did on the steamer. (Capt. Jim Blum.)

This powder room, with the round windows, was built in approximately the same area on the ballroom or second deck as the old original Glamour powder room. The rounded entrance is also reminiscent of the old powder room. (Capt. Jim Blum.)

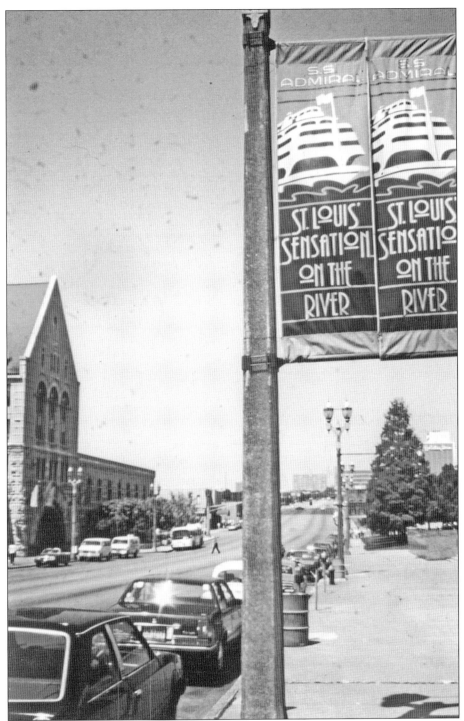

To help make the grand announcement that the *Admiral* venue was finally opened, huge signs were placed on the lamp posts in downtown St. Louis. This location is at Union Station on Market Street, which is about 12 blocks west from the levee and was built to handle train traffic to the 1904 World's Fair. (Capt. Jim Blum.)

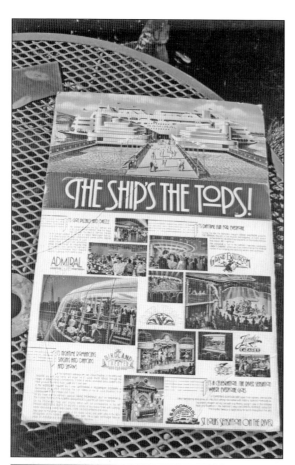

This poster was produced before the SS *Admiral* entertainment center was open. It used the slogans, "St. Louis Sensation on the River," and "The Ship's The Tops!" The drawings were artist's conceptions of what was to come. (Capt. Jim Blum.)

This is an artist's conception of the style of signage used on each deck. In this case, the original ballroom was to be divided into three separate venues. (Capt. Jim Blum.)

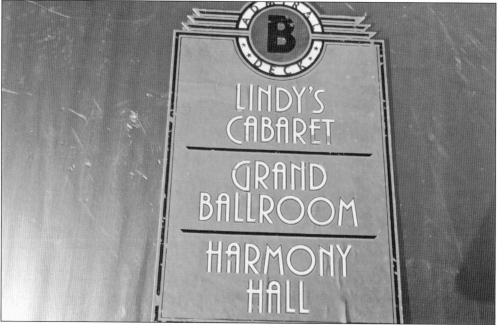

After 1991, and little success as an entertainment center, the owner John Connelly decided to make the *Admiral* into a casino. The process of remodeling the boat to casino included making the ballroom ready for game machines. (Capt. Jim Blum.)

The mezzanine had been partially used for sewing rooms and changing centers, and was also made ready to house a casino's needs. (Capt. Jim Blum.)

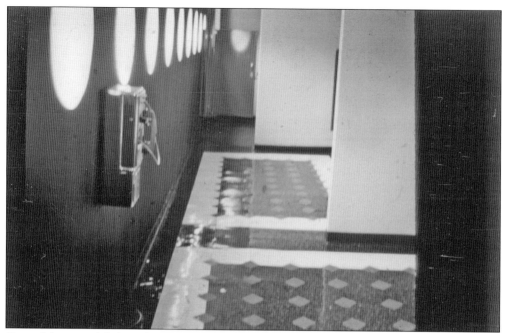

One of the remodeled men's restrooms on the Casino *Admiral* was decorated in red and black with the old round windows. In the days before personal cellphones, the pay telephone was a necessity. (Capt. Jim Blum.)

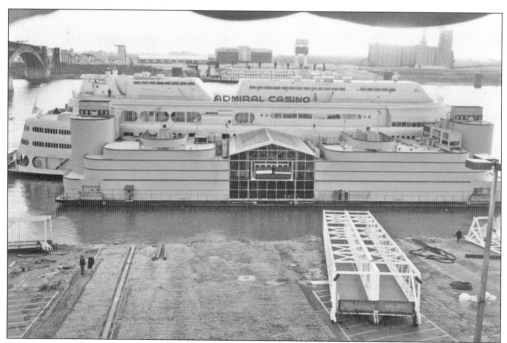

On the outside of the casino was a large sign. The addition had been repainted white. At this point, it was still located at the foot of Washington Avenue downtown. (Capt. Jim Blum.)

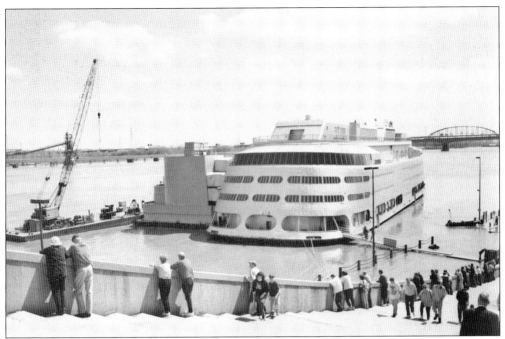

In 1998, the Casino *Admiral* was accidentally hit by a towboat, leaving the boat hanging onto the shore by just one line until help arrived. It was a time of high water, so spectators watched from the steps of the Jefferson National Expansion Memorial. (Capt. Jim Blum.)

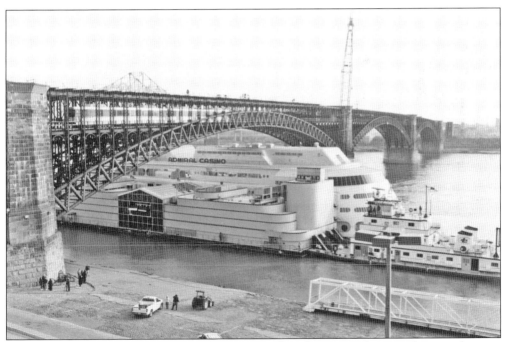

After the accident with the towboat, the Casino *Admiral* was moved using a large towboat, to just north of the Eads Bridge. It was a close fit under the bridge. (Capt. Jim Blum.)

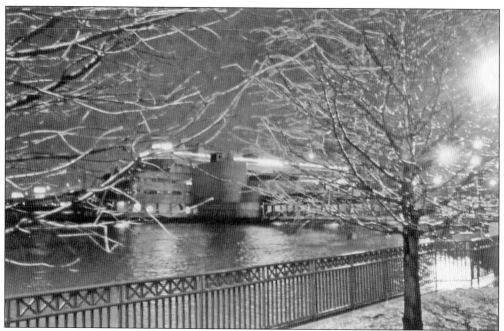

This night scene was captured through the young trees on the levee. It shows the lighted *Admiral* sign and the stage out to the casino. The lights from the casino glow in the river. (Capt. Jim Blum.)

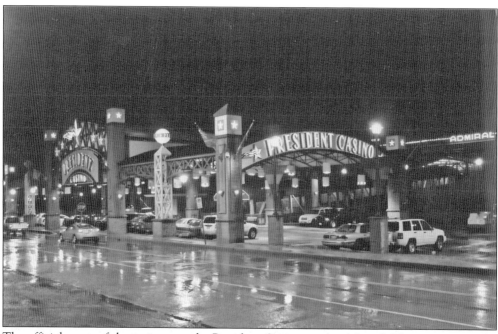

The official name of the casino was the President Casino on the *Admiral*. The entrance to the casino above Eads Bridge was made more welcoming by the glow of lights at night in the rain. (Capt. Jim Blum.)

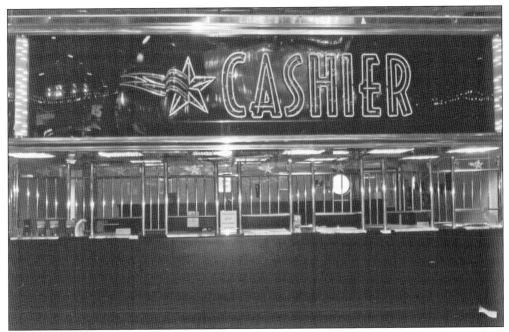

The cashier booths were made to look like old time bankers' cages. When the casino opened, all games used tokens, which could be purchased and exchanged at the cashier booths. Later, paper currency was used in the machines. (Capt. Jim Blum.)

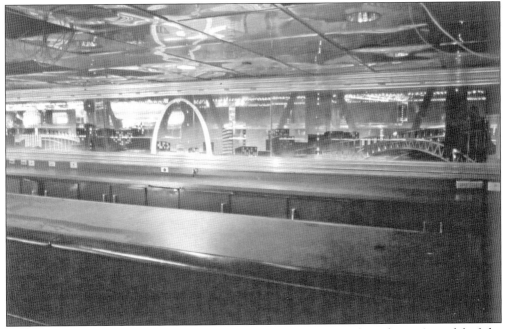

There were several bars just in case someone needed to quench their thirst. A model of the Gateway Arch was etched in the glass of the backbar. (Capt. Jim Blum.)

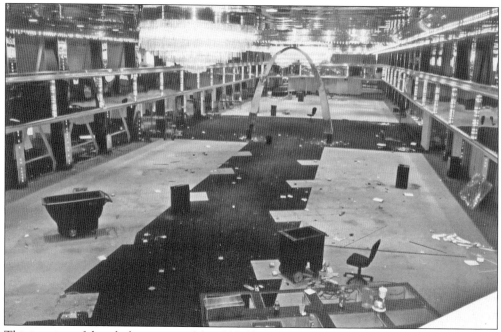

This is a view of the whole expanse of the old ballroom without gaming machines in place. There was a large model of the Gateway Arch in the center of the room. (Capt. Jim Blum.)

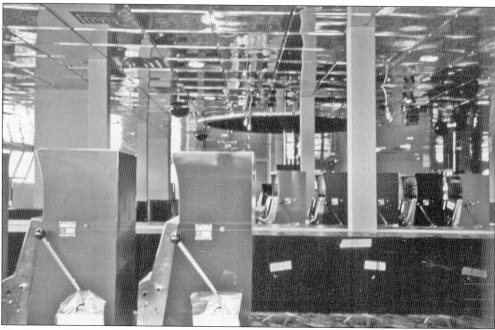

Gaming machines with large identifying signs attached wait to be set in place. Besides the slot machines, a whole variety of games was available. (Capt. Jim Blum.)

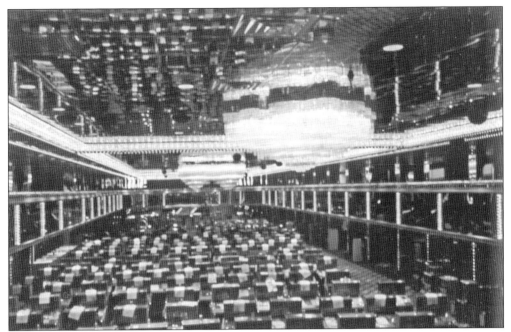

The gaming machines are in place under the huge chandelier hung from the high ceiling. (Capt. Jim Blum.)

There was a covered walkway leading to the entrance to the Casino *Admiral*. On the left are the gangplanks, and ahead is Eads Bridge. (Capt. Jim Blum.)

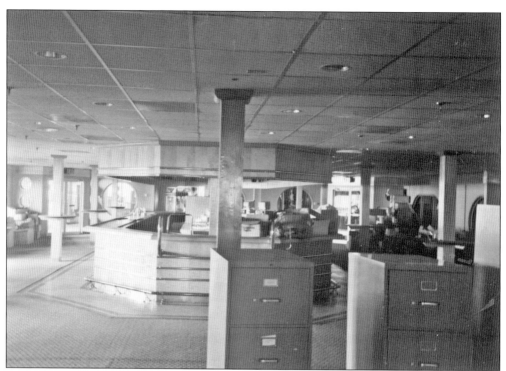

Another casino bar; this one was located on the first deck in about the same location as the former popcorn/souvenir stand on the steamboat. (Capt. Jim Blum.)

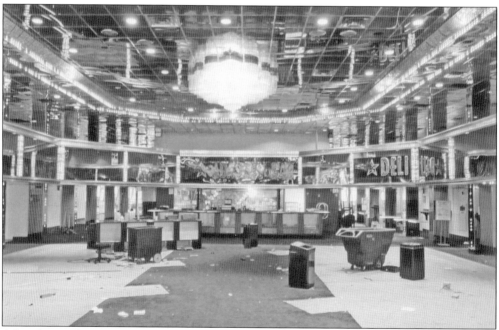

After closing the casino, the chandelier is still in place, but the gaming machines are gone, and trash litters the deck. The land-based casino had opened, and the river venue was no longer needed. (Capt. Jim Blum.)

Nine

THE ENDING

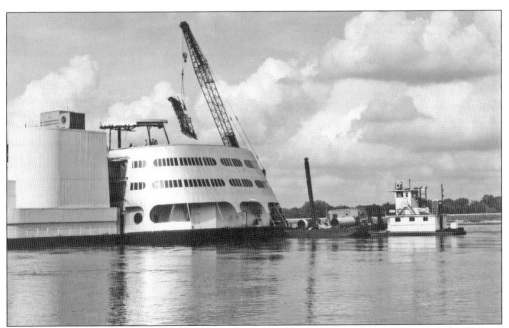

The Casino *Admiral* was emptied of furniture and equipment, and the wrecking could begin. Here, the top deck is already gone, and a large crane removes the last sections of the fourth deck. (Capt. Jim Blum.)

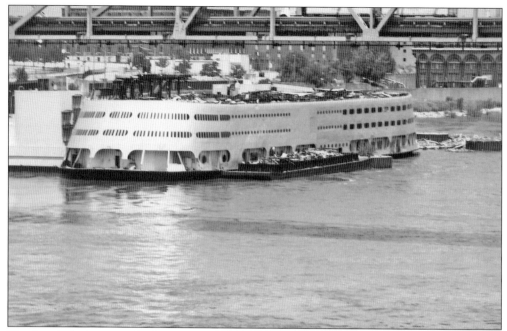

The fourth deck is completely gone, and the big boat sits just north of the Eads Bridge waiting for further demolition. Trees from the upper levee can be seen, and years of drift is piled up at the bow in the water. (Capt. Jim Blum.)

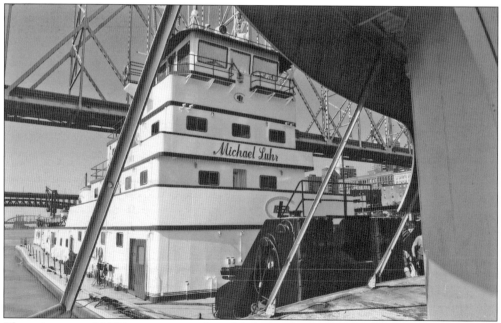

The twin-screw, 6,000-horsepower towboat *Michael Luhr* was hired to push the *Admiral* down river. This photograph was taken in July 2011. (Capt. Jim Blum.)

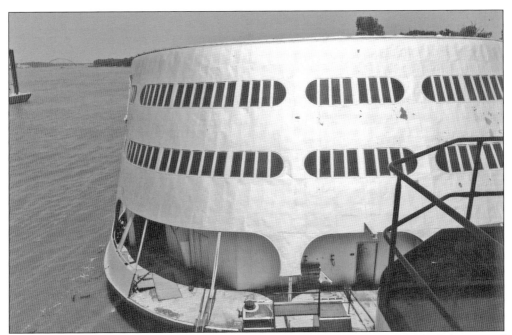

The knees of the towboat *Michael Luhr* have a firm grasp of the boat. The pilot had this view of the windows of the old cabin, the landscape, and ahead, the Jefferson Barracks Bridge. (Capt. Jim Blum.)

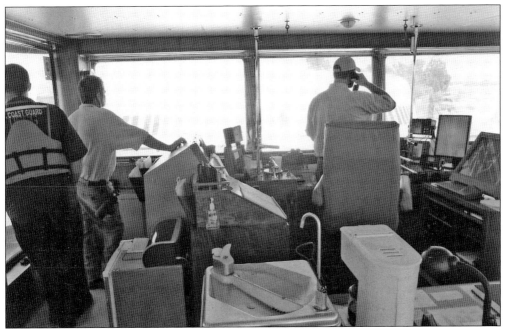

Inside the modern pilothouse of the towboat *Michael Luhr*, the crew is busy. Their burden is headed for the scrapheap, but they must still be careful. (Capt. Jim Blum.)

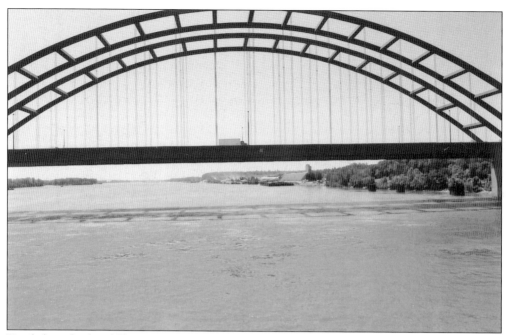

Headed south, the old boat passes under the Jefferson Barracks Bridge one last time, with a lone truck as witness. The destination was Luhr Bros. Inc. of Columbia, Illinois. (Capt. Jim Blum.)

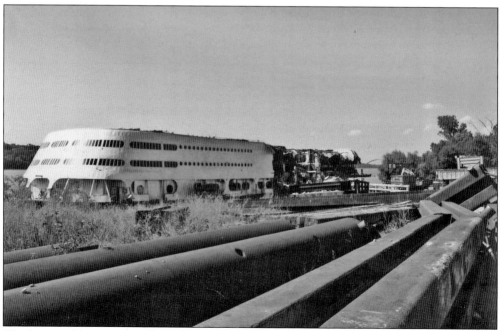

The big metal boat rests at the Luhr Bros. yards, with one fourth of it already broken up. The parts were sold for scrap. (Capt. Jim Blum.)

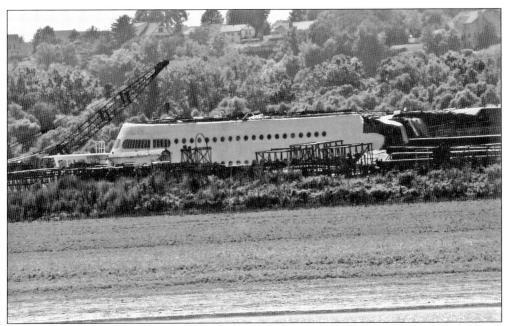

Here, the *Admiral* is still afloat on the Mississippi River, but the flooded cornfield in the foreground makes it appear to be high and dry. (Capt. Jim Blum.)

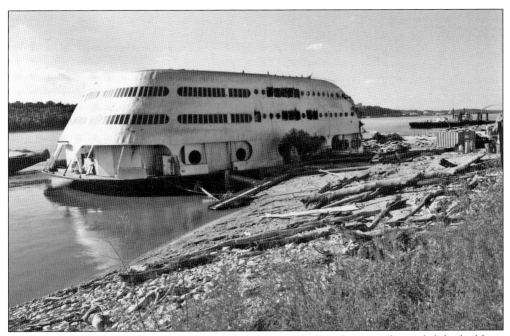

The whole front half of the *Admiral* is gone, from top deck to barge. What is left looks like a miniature boat. (Capt. Jim Blum.)

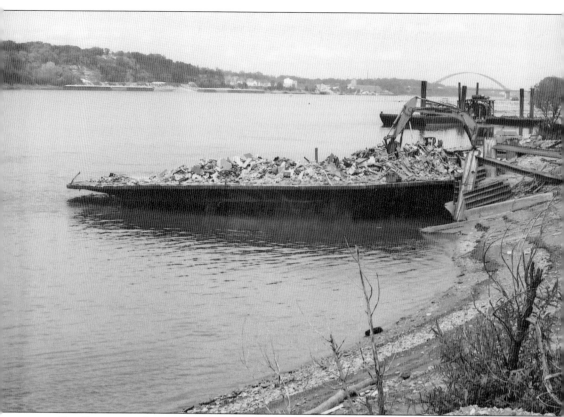

Smaller scraps along with odds and ends of the *Admiral* sit on the riverbank awaiting pickup. Despite the fact that the *Admiral* is gone, memories of her joyful days thankfully remain vivid. (Capt. Jim Blum.)

BIBLIOGRAPHY

Captain William F. and Betty Streckfus Carroll Collection at the St. Louis Mercantile Library, University of Missouri.

Department of Commerce Bill of Sale of Enrolled Vessels. St. Louis, Missouri: St. Louis Mercantile Library, 1935.

List of Masters, Mates, Pilots and Engineers of Merchant Steam and Other Motor Vessels: licensed during the year ended 1897. Washington, DC: Government Printing Office, 1897.

Meyer, Dolores Jane. "Excursion Steamboating on the Mississippi with Streckfus Steamers, Inc." PhD dissertation. St. Louis University, 1967.

Way, Frederick Jr. *Way's Packet Directory, 1848–1983: Passenger Steamboats of the Mississippi River System since the Advent of Photography in Mid-Continent America.* Akron, OH, 1983.

Jefferson National Expansion Memorial. National Park Service. www.nps.gov/jeff/index.htm.

INDEX

THE HERMAN T. POTT NATIONAL INLAND WATERWAYS LIBRARY

The Herman T. Pott National Inland Waterways Library is a special library within the St. Louis Mercantile Library, one of America's great historical research libraries. Serving St. Louis and the nation since 1846, the Mercantile Library was founded by a group of businessmen who possessed a deep interest in and close relationship to the nation's inland rivers, particularly the Mississippi. Throughout its history, individuals active in waterways businesses have been associated with the Library. In 1985, the Mercantile Library built upon this long heritage of association with the river by greatly expanding its waterways-related holdings and establishing the Herman T. Pott National Inland Waterways Library as a special collection.

One University Boulevard
St. Louis, Missouri 63121
314-516-7241
www.umsl.edu/mercantile/pott/index.html

DISCOVER THOUSANDS OF LOCAL HISTORY BOOKS
FEATURING MILLIONS OF VINTAGE IMAGES

Arcadia Publishing, the leading local history publisher in the United States, is committed to making history accessible and meaningful through publishing books that celebrate and preserve the heritage of America's people and places.

Find more books like this at
www.arcadiapublishing.com

Search for your hometown history, your old stomping grounds, and even your favorite sports team.

Consistent with our mission to preserve history on a local level, this book was printed in South Carolina on American-made paper and manufactured entirely in the United States. Products carrying the accredited Forest Stewardship Council (FSC) label are printed on 100 percent FSC-certified paper.

MADE IN THE USA